INVERNESS
THROUGH TIME
Adrian Harvey

AMBERLEY

Acknowledgements

For the most part the vintage photographs in this volume were sourced from the Scottish Highlander Photo Archive which houses the collection of the Andrew Paterson Studio, the Joseph Cook Collection of Old Inverness, and the massive postcard collection of Roderick Maclean. Thank you to Andrew Chalmers, Fergus Weir, David Henderson and Roderick Maclean.

Other contributors I would like to thank include Dr Tony Smith, Willie Morrison, Robert Paterson, Aithne Barron, Hector Macdonald, Peter Snowie, Norma Grant, Jeff Macleod, Ishbel Macqueen, Anne Chisholm, Irene Jones, Sheila Burnett, Hamish Campbell, Tony Hogg, Rory Macleod, James Miller (Patricia Neuman), James M. Pirrie, Duncan Mackintosh and Am Baile. Thank you too to the many individuals who helped facilitate access to various offices and rooftops in order to take the comparison photographs.

For contributions behind the scenes, I thank Dave Conner, especially for providing the modern image of the Town House without scaffolding (which only went up the day before the scheduled shoot), the Rose Window in storage and for bringing to my attention various nuggets of valuable information.

Some related and interesting websites for further reading include:
www.scottishhighlanderphotoarchive.co.uk
www.patersoncollection.co.uk
www.lostinverness.co.uk

This book is dedicated to my late mother Dorothy.
It was the last project I was working on that she knew about.

First published 2015

Amberley Publishing
The Hill, Stroud
Gloucestershire, GL5 4EP

www.amberley-books.com

Copyright © Adrian Harvey, 2015

The right of Adrian Harvey to be identified as the Author of this work has been asserted in accordance with the Copyrights, Designs and Patents Act 1988.

ISBN 978 1 4456 4199 7 (print)
ISBN 978 1 4456 4207 9 (ebook)

British Library Cataloguing in Publication Data.
A catalogue record for this book is available from the British Library.

Typesetting by Amberley Publishing.
Printed in the UK.

Introduction

Describing Inverness in the 1950s, Daphne Mould wrote:

> ... the River Ness a silver ribbon through its heart; a red sandstone castle above the stream; the Highland hills to the one side and the blue water of the Moray Firth and the fertile eastern lowlands upon the other. The Capital of the Highlands it has been styled, and yet, strictly speaking, it stands outside the mountain country proper, on the border line between the hills to the west and the lowlands to the east.

These words from over sixty years ago still ring true. Inverness is the gateway to the Scottish Highlands, where beautiful landscapes merge with a dramatic past. Historically it is one of the oldest towns in Scotland and has been the junction of ancient trade routes since AD 565.

Situated at the head of the Moray Firth and the mouth of the Great Glen Inverness is a terminus and starting point for travel and traffic, living up to its other appellation; the Hub of the Highlands.

Inverness was only granted city status in 2000, but it has always been considered the Highland capital irrespective of such distinctions. In fact, in the sixth century it was the capital of the Pictish kingdom. For centuries, Inverness has been central to the passing parade of historical intrigue, tragedy and triumph of the great Scottish Highland clans.

While this Royal and Ancient Burgh is recorded as going back thousands of years, it doesn't look like an old town today. Little remains of its long history because it was sacked and burned so many times. Inverness developed on the eastern shore of the River Ness around the Castle Street, Church Street, High Street, and Bridge Street area, although there were also houses along the west bank. The gardens behind these houses were gradually built over, with narrow closes for access, some of which still survive.

In the twelfth century the main street ran north to south, linking the castle to the church. Three other routes converged on the tollbooth where the markets would take place in what later became known as the Exchange. At this time there was a flourishing trade in fish, wool and furs. The high street became a centre for merchants. Early houses were built with booths which opened onto the street, in front of which sat people from the town displaying their wares on the ground.

From the thirteenth century there was a shipbuilding industry here too, as Inverness was also a busy port during the Middle Ages. Nearby is the site of the Battle of Culloden, the last battle fought on British soil, and during the years which followed the Forty-Five Rebellion trade supplanted war and the town began to acquire its modern aspect. The events of the past had left little of its ancient structures, but new buildings were taking their place.

There were no cobbles in the streets, no public drains or water supply before about 1830. Epidemics, including cholera, occurred from time to time. The houses were mostly thatched, and this, together with the congestion, led to frequent fires.

The castle was again rebuilt in 1834 and, to facilitate trade the Caledonian Canal, opened in 1822. The disastrous flood of 1849, which swept away the seven-arched stone bridge built in 1684, completely submerged low-lying areas for three days.

The basic street layout of yesteryear still exists, but the modernisation and developments between the 1950s and 1970s saw much of old Inverness disappear. As John Pearson wrote in 1987, 'In many a case these new buildings have contributed little to the townscape and character of the town compared with the buildings they replaced.'

In fact, one sad note about the present volume is that one of the most oft-used words contained in the text is 'demolished'. There are exceptions, including a house which dates from 1592 and Dunbar's Hospital of 1688, both in Church Street.

Inverness is the largest conurbation and is the main service and administrative centre for the region but not formally a capital of anything. However, with an enviable central location at the mouth of the River Ness on the Moray Firth, Inverness will always provide a magnet for visitors and shoppers from all points of the globe.

In the words of Neil M. Gunn, 'No one can say he has seen Scotland who has not seen the Highlands, and no one can say he has been to the Highlands who has not stopped to sample its spirit in Inverness.'

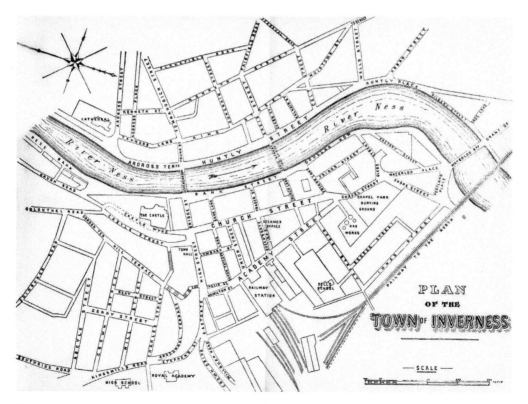

The town plan of Inverness is sourced from a 1929 guide book, and provides easy, ready reference to the sites portrayed in the vintage images.

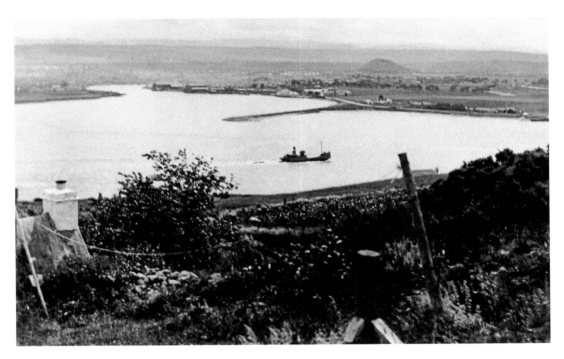

Inverness from the Hills of Craigton, North Kessock, *c.* **1920 and 2015**

The name Inverness derives from the Scottish Gaelic Inbhir Nis meaning 'Mouth of the River Ness' and the town that grew along the banks of the river was one of the chief Pictish strongholds. A small steam cargo boat is here towing a pilot rowing boat towards the entrance of the Caledonian Canal. In the distance centre right is the distinctive shape of the Tomnahurich Cemetery hill.

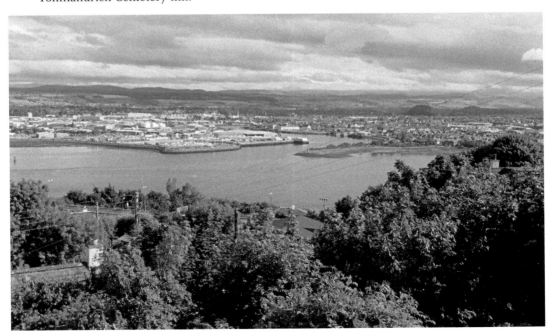

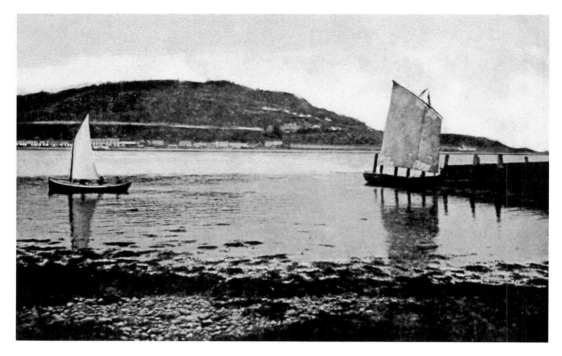

Looking across to North Kessock on the Black Isle, *c.* 1907 and 2014

There has been a ferry crossing between North and South Kessock since the fifteenth century with the service linking the Black Isle with Inverness. It continued until the Kessock Bridge opened in 1982, seen on the right. The ferry crossing was sail powered until 1907 and could take over twenty minutes depending on wind and tide. A ferry trip was a favourite outing for families, but could be shared with cattle, sheep or pigs on their way to market.

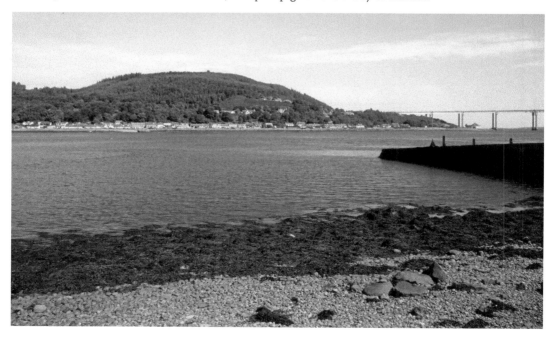

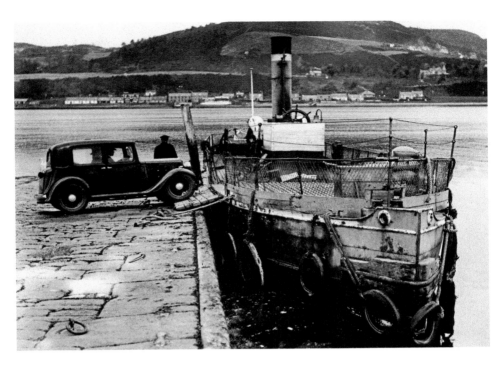

SS *Nellie* at South Kessock, March 1936 and 2015
Kessock ferry tariffs were often a source of contention. In 1887 there were objections to paying 6*d* for a cow, 1*d* for a sheep and 2*d* for carrying 'small pigs in bags'. One of the ferries sank in a storm in 1894 resulting in the deaths of three ferrymen and three coastguards who were trying to rescue them. The service was privately run until 1939 when it was taken over by local authorities, eventually closing in 1982.

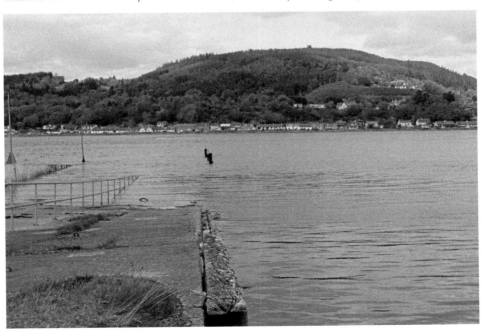

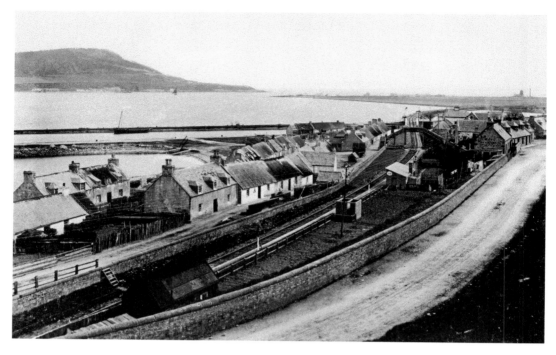

Clachnaharry, 1890s and 2015

Clachnaharry, a former fishing village, lies at the entrance to the Caldedonian Canal on the south shore of the Beauly Firth, on the line of the main road and railway west from Inverness. The older part of the village lies to the left of the railway line and the canal entrance can be seen in the centre with South Kessock and the Black Isle beyond.

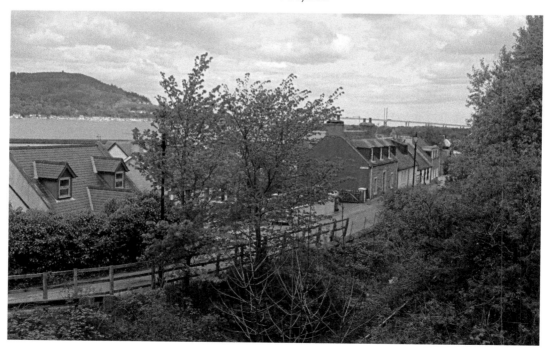

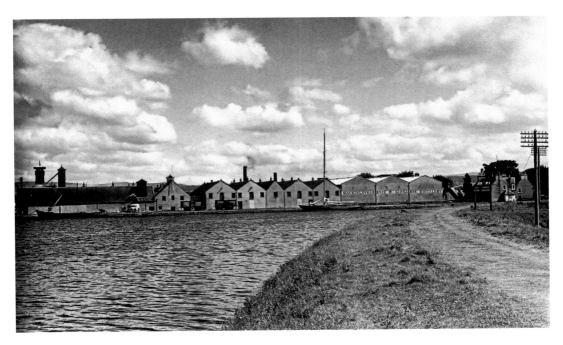

Glen Albyn Distillery on the Water of the Muirtown Basin, *c.* 1920 and 2015
First established by Inverness Provost James Sutherland in 1846, a new distillery was built on the south bank of the Caledonian Canal in 1884. Used as a US naval base during the First World War, it closed between 1917 and 1919 until acquired by Mackinlays & Birnie of Glen Mhor distillery in 1920. The distillery shut in 1983 and the buildings were knocked down in 1988 to make way for a retail development. The distillery had its own railway line connected to the main Highland Railway.

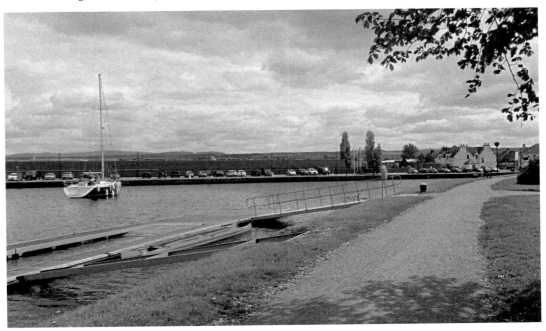

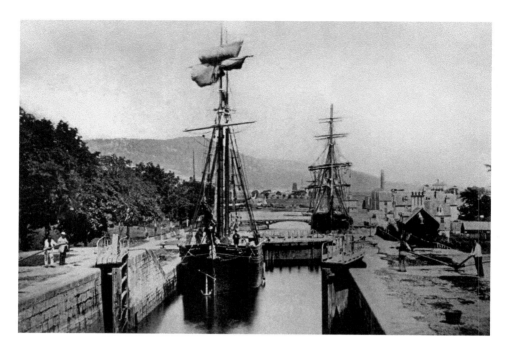

The Caledonian Canal, *c.* 1884 and 2015

The Inverness schooner *Margaret Reid* westward bound through Muirtown Locks of the Caledonian Canal. The road swing bridge can be seen in the middle distance and beyond is the Glen Albyn Distillery, visible beside the Muirtown Basin. The canal was a triumph of civil engineering designed by Thomas Telford and William Jessop. Built between 1803 and 1822 it connected a series of lochs along 60 miles of the Great Glen geological fault between Inverness and Fort William.

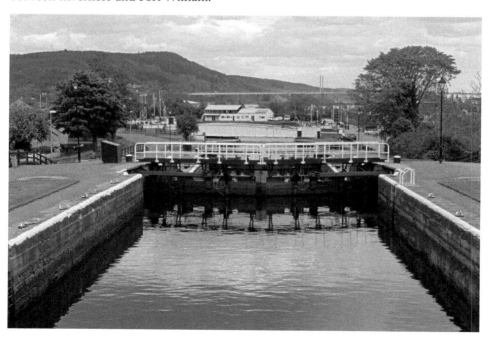

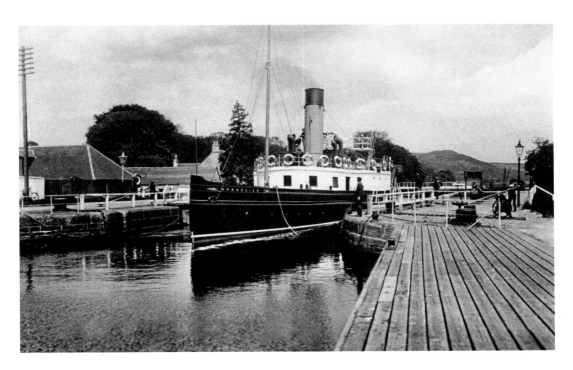

The Caledonian Canal, *c.* 1933 and 2014

The *Gondolier* in the canal. Introduced in 1866 she was retired in 1939 and used as a block ship at Scapa Flow in Orkney. The canal allowed vessels of up to 500 tons to sail from one side of the country to the other, but it was blocked for three weeks in 1881 when two schooners wedged themselves together in the sea lock. They hung in mid-air as the tide receded and then crashed to the bottom. Both were eventually salvaged.

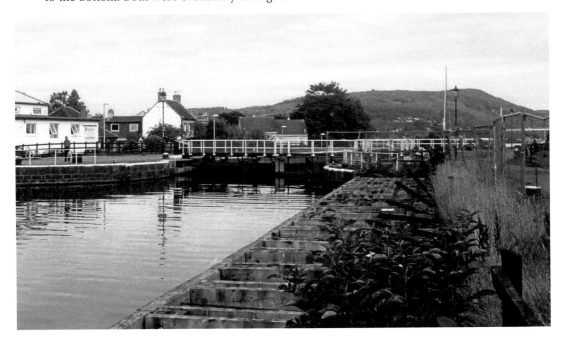

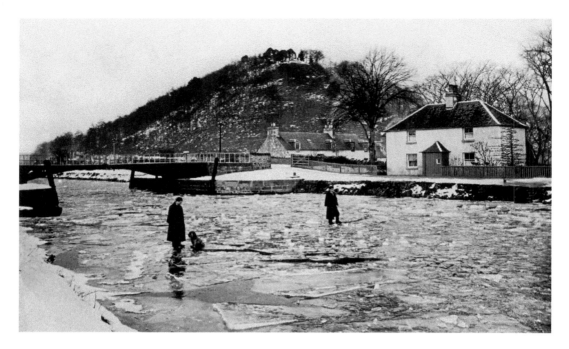

Bridge Keeper's House and Tomnahurich Hill, 1900s and 2014
The Caledonian Canal connects the Scottish east coast at Inverness with the west coast at Corpach near Fort William. Tomnahurich Bridge alongside the bridge keeper's house dates from 1813. The bridge was replaced by the current swing bridge in 1938. Only one third of the entire length of the canal is manmade, the rest being formed by Loch Dochfour, Loch Ness, Loch Oich and Loch Lochy. There are twenty-nine locks, four aqueducts and ten bridges in the course of the canal.

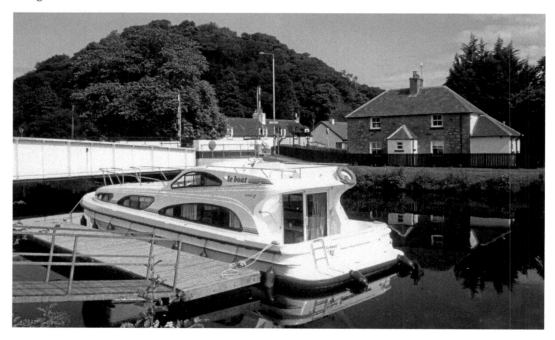

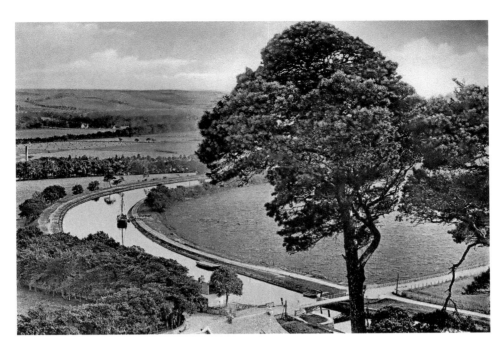

The Canal and Essich Moor from Tomnahurich Hill, 1900s and 2015

The canal was conceived to provide employment to the Highland region after the Highland Clearances, which had deprived many of their homes and jobs. The canal also provided a safer passage for sailing ships from the north east of Scotland to the south west, avoiding the route around the coast via Cape Wrath and the Pentland Firth. Tomnahurich Hill is a prominent landmark and until the mid-19th century provided a natural grandstand and course for horse racing around its base.

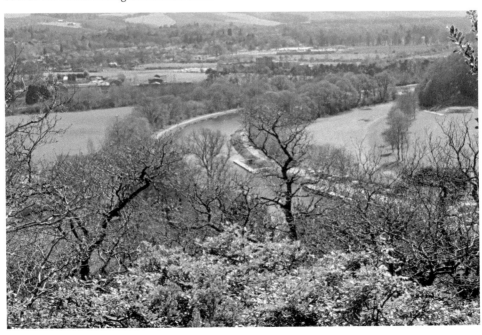

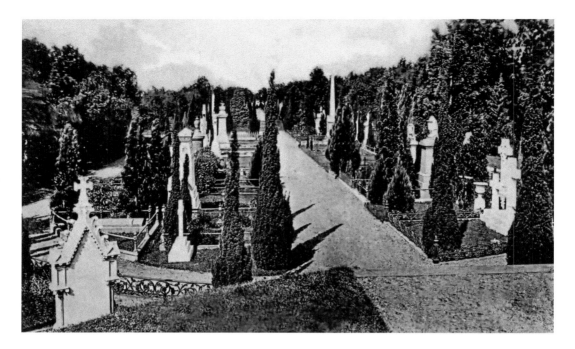

Tomnahurich Cemetery, 1900s and 2014

Tomnahurich in Gaelic means 'hill of the yew tree' although it's commonly called the 'hill of the fairies'. In 1864 it became the main burial ground for the growing town. Cost had been a factor as the price of agricultural land for cemetery use would have been considerable and frowned upon as wasteful. After completion of access to the summit (213 feet) and associated landscaping, the burial ground was opened for use, the first interment being a young child in May 1864.

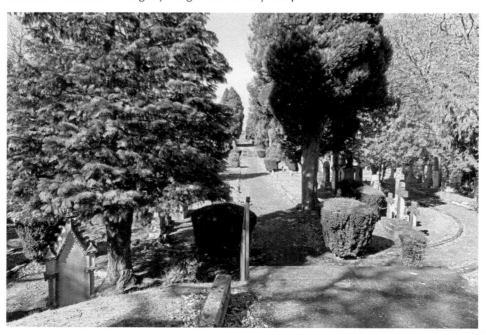

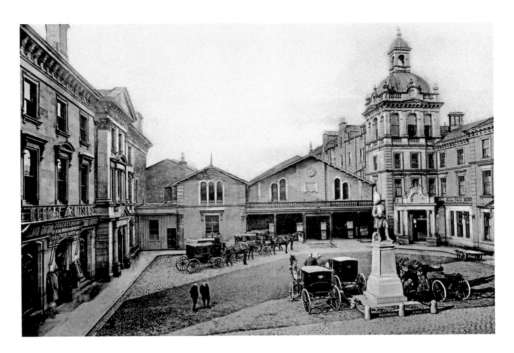

Station Square, Academy Street, *c.* 1898 and 2014
The first sight of Inverness for many early tourists was Station Square, the entrance being designed by engineer Joseph Mitchell. The Station Hotel, now the Royal Highland Hotel, was built in 1859 and considerably extended during the 1860s, although its dome was removed many years ago. The original entrance was moved from Academy Street to the right corner beside the station in 1898. The railway opened in 1855 with a connection to Nairn and the Cameron Monument was the departure point for cab excursions to places of interest.

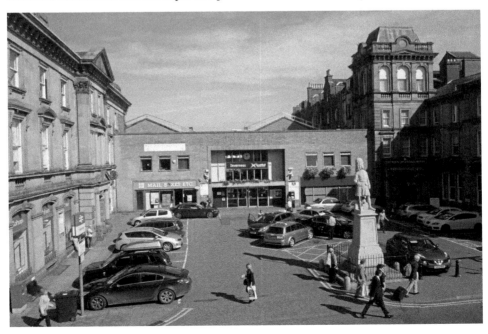

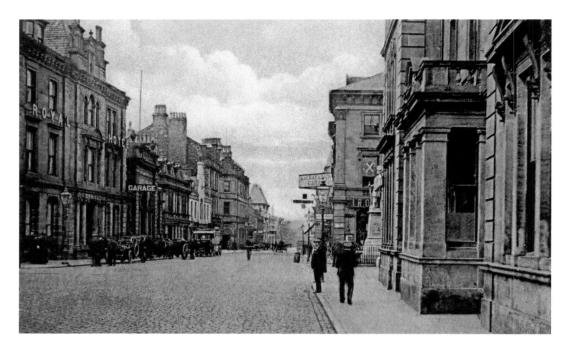

Academy Street, c. 1920 and 2015
Previously called New Street, Academy Street was laid out as a main thoroughfare in 1765 and was the town's principal shopping street and entry for visitors arriving by train. It was renamed when the Inverness Royal Academy opened in 1792, a building which was seriously damaged by fire in April 2015. Scaffolding to prop up the shell has closed half the street which is at the heart of an area earmarked for a multi-million-pound regeneration project. It's hoped the façade can be saved.

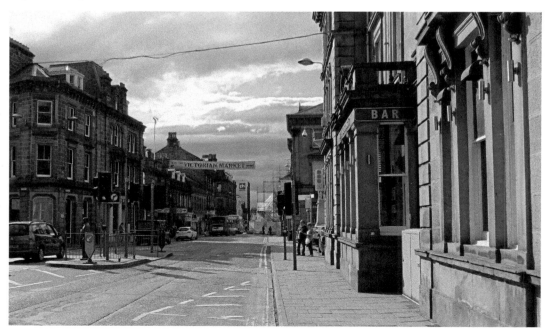

Cameron Highlanders Monument, Station Square, c. 1950 and 2014

The memorial to the Queen's Own Cameron Highlanders, taken from Room 104 of the Royal Highland Hotel. It pays tribute to over 140 officers and soldiers, including a boy soldier, who lost their lives during the campaigns in Egypt and the Sudan from 1882 to 1887 and as a result of further campaigns in 1898. Sculpted by George Edward Wade in white Portland stone with granite steps, it was unveiled by Cameron of Lochiel in July 1893.

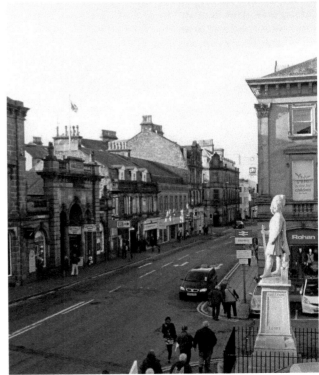

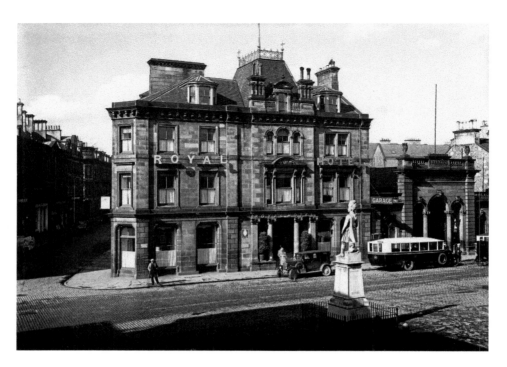

Royal Hotel and Victorian Market, Academy Street, December 1930 and 2014

Opposite Station Square and taken from the roof of the entrance portico to the Station Hotel, now the Royal Highland Hotel (via Room 128), is the first Royal Hotel building. Now the home to the Clydesdale Bank, it sits on the corner of Academy Street and Union Street. To the right is the main entrance to the Victorian Market with its Corinthian arches and animal carvings on the keystones. Built in 1870 it was originally known as the New Market.

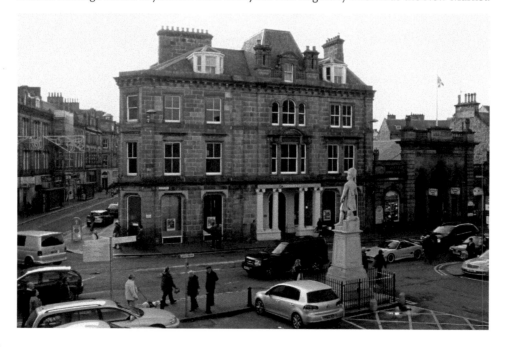

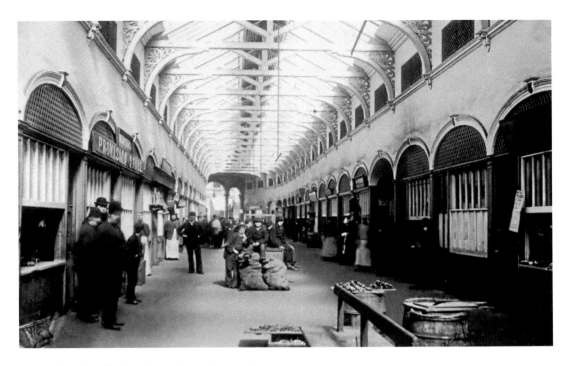

Victorian Market Arcade, c. 1870 and 2015

The 1870 sandstone entrance in Academy Street survived a fire in 1889 and was incorporated into the 1890 rebuild at a cost of £7,158. The archway leading from Church Street has been partly worn away by the sharpening of the fish merchants' knives from when it was a fish market. There were no permanent stands, each stallholder rented a table from the town council at 6*d* per day. The market connects all four surrounding streets and houses small shops and traders.

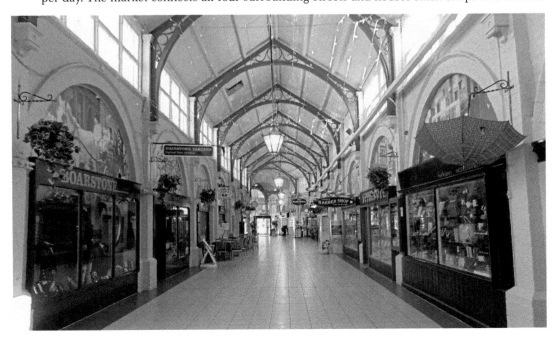

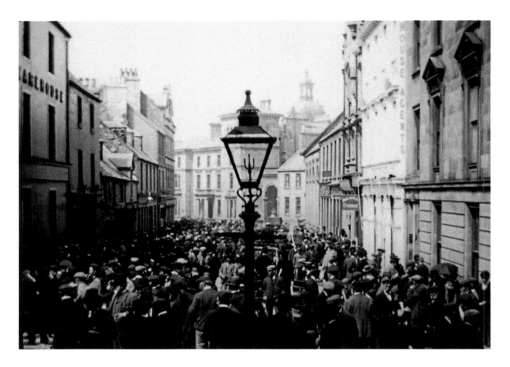

Inglis Street, 1890s and 2015

At the top end of Academy Street lies Inglis Street, location of the Martinmas Market which used to be held each year towards the end of November. Also known as the Cheese Market as butter and cheese from the small farms and crofts around the town were a regular produce of the fair. The Station Hotel (now Royal Highland Hotel) is in the centre.

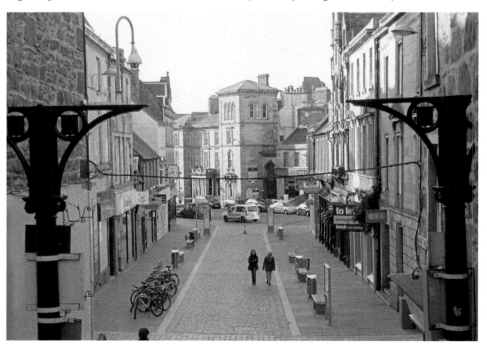

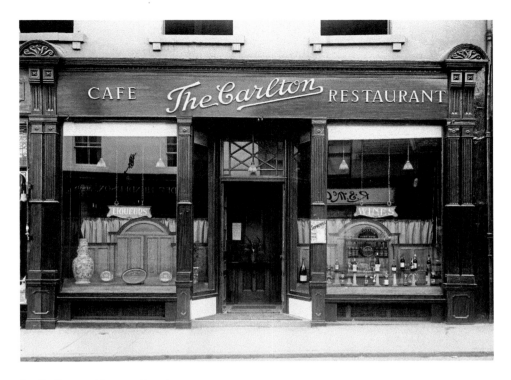

Inglis Street, May 1936 and 2015

Formerly the shop of William Grigor & Son, wine and spirit merchants, the Carlton Cafe was opened in the autumn of 1927. It was later taken over by a Mr Cameron and a cocktail bar was added to the upstairs rooms and renamed the Carlton Café Restaurant in May 1936.

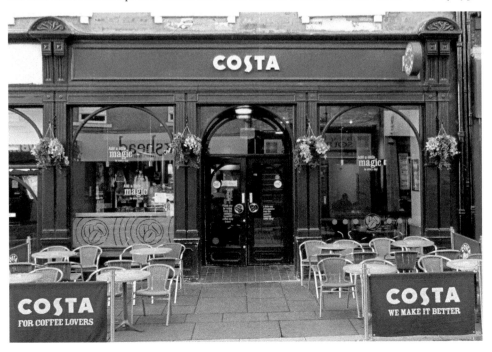

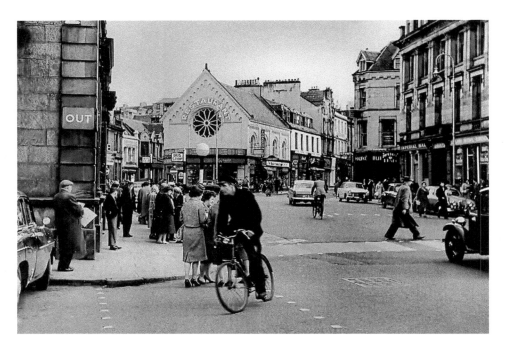

Inglis Street and the Rose Window from Station Square, 1961 and 2015

Stewart's Restaurant located in the former nineteenth-century Wesleyan Chapel at the corner of Inglis Street and Hamilton Street at the top end of Academy Street. It was demolished to facilitate the Eastgate Shopping Centre development in the early 1980s. The distinctive rose window, which was supposed to have been incorporated in the new Eastgate Centre is still in storage at the Council's Diriebught depot and it's hoped that one day it will be incorporated into a future building development.

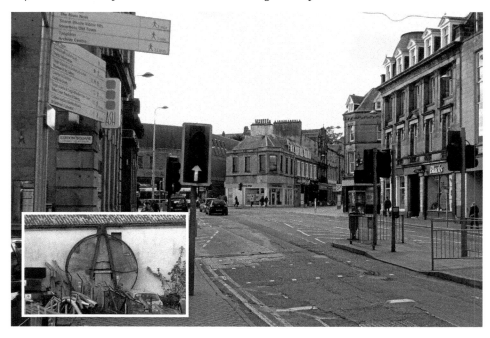

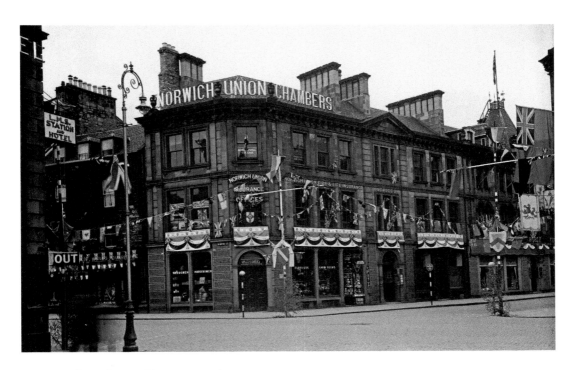

Academy Street, May 1937 and 2015

The Norwich Union Chambers on the corner of Academy Street and Union Street, bedecked with decorations for the Coronation of King George VI in May 1937. Taken from Station Square, the first floor signage today still reads Norwich Union-Scottish Union Insurance Group and the corner florist on the ground floor is now the administrative HQ of the Caledonian Sleeper franchise.

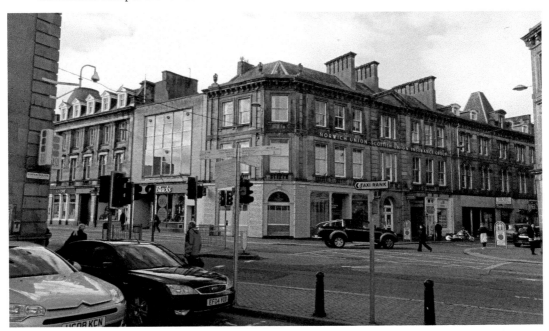

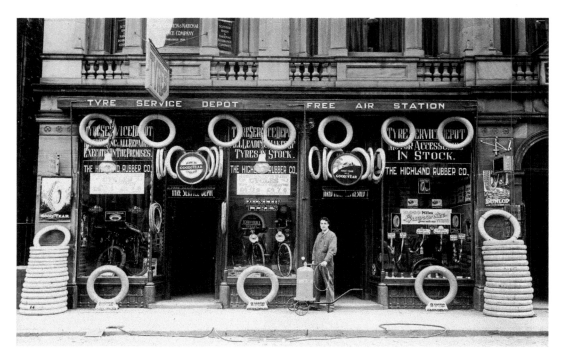

Academy Street, June 1929 and 2015
The Tyre Service Depot and Free Air Station of the Highland Rubber Co. in Academy Street. Dealing in Goodyear and Dunlop tyres for cars and bikes, they offered a 10,000-mile guarantee on their products. Now an Indian restaurant, the building façade underwent a complete refurbishment in 2015.

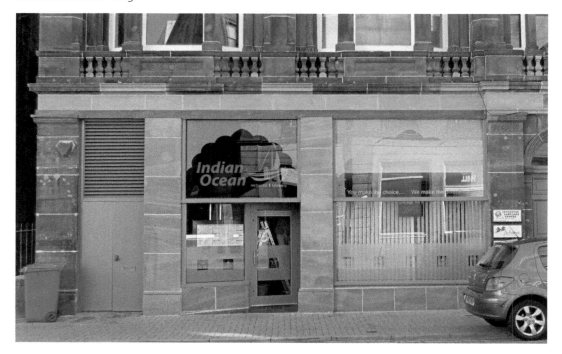

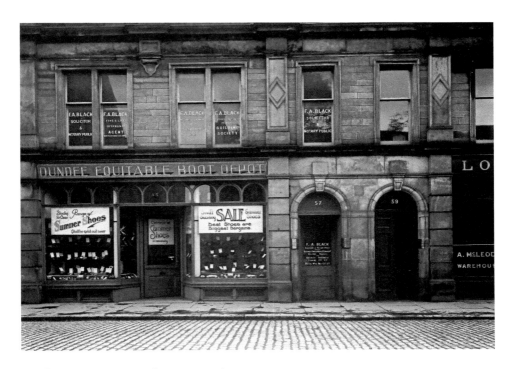

Academy Street, November 1927 and 2015

The Dundee Equitable Boot Depot was established in Dundee in 1867. The business was renamed D. E. Shoes but the retail chain owned by William Smith Ltd failed to find a buyer for its business during difficult economic times, and ceased trading with the closure of twenty-five shops in 2013. Until then, D. E. Shoes was still located in the same building on Academy Street.

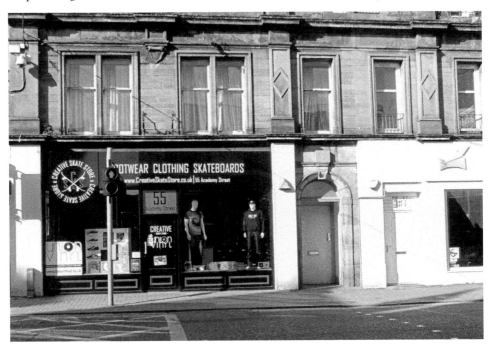

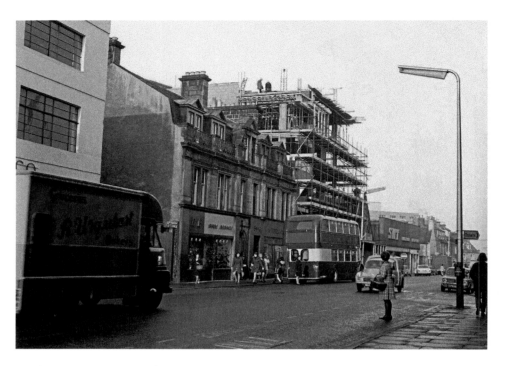

Academy Street, 1971 and 2015
Building and construction of Caledonia House, now the Penta Hotel in Academy Street. Originally the site of the Central Hall Picture House of 1912 (inset), the town's only concert hall from 1931 until it was demolished in 1971. It was renamed Empire Theatre in 1934. D. E. Shoes occupied the corner site for many years, next to the rear car park entrance of the Cummings Hotel (which is now a nightclub).

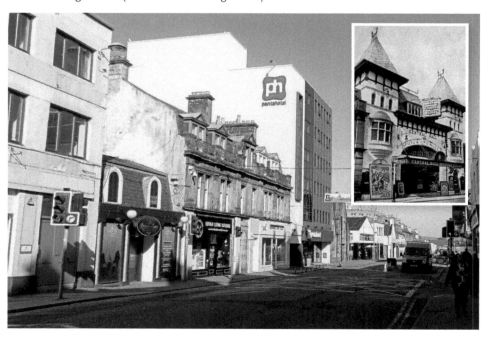

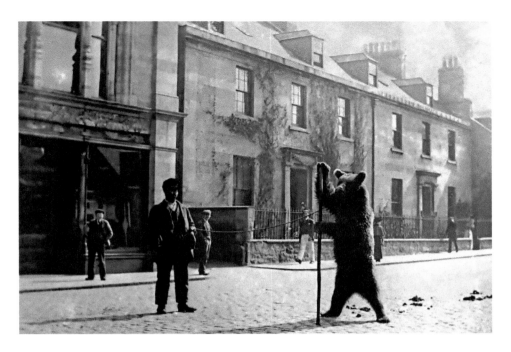

Academy Street, *c.* 1895 and 2014

Travelling groups of musicians, showmen and entertainers were common during the 1880s–1890s. Performing bears were a regular attraction like this one standing outside the old Rose Street Foundry building. Behind it are Nos 92–94, built *c.* 1830 as residential villas for 'respectable families.' The listed building was demolished in 2014 shortly after this picture was taken due to 'the indiscriminate and inappropriate use of cement rendering to the principle facade and the extensive use of cement pointing and rendering to the rear.'

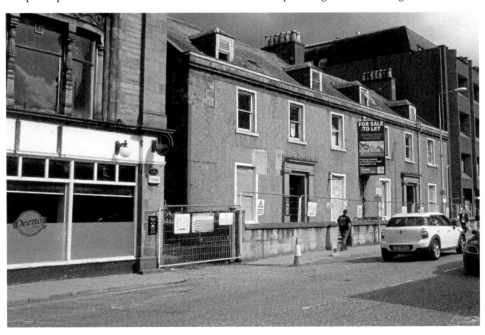

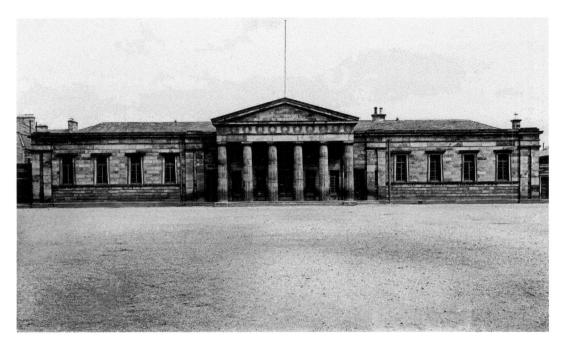

Bell's School in Farraline Park, off Academy Street, August 1930 and 2015
Clergyman Dr Andrew Bell made a fortune with the East India Company. When he died in 1832 he left stocks for founding educational establishments throughout Scotland. Designed by William Robertson in Greek Revival style with Doric columns and pediments, this building was completed in 1841 to house Bell's Institution in Farraline Park. The school closed in 1937. It has since housed an arts centre, courthouse, police station and from 1981 the public library. The playground is now Inverness Bus Station.

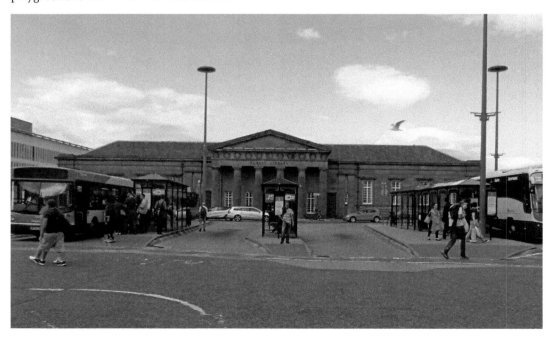

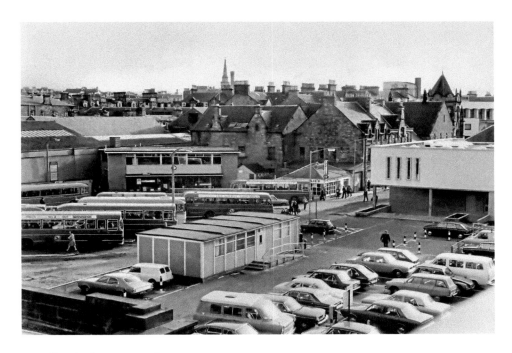

Farraline Park, 1970s and 2015

The playground was once used as a parade square for two militia units. The Ministry of Defence took over the Bell's School prior to the Second World War. The playground became a training area and later an aircraft scrap yard. The Bus Station has been located in Farraline Park since the late 1940s. There have been many changes in layout and design over the years, the most recent terminal and bus stances opening in 2000. The Spectrum Centre, on the right, is bricked around the old Artillery Militia Hall.

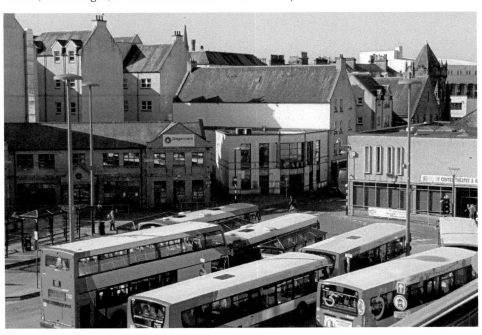

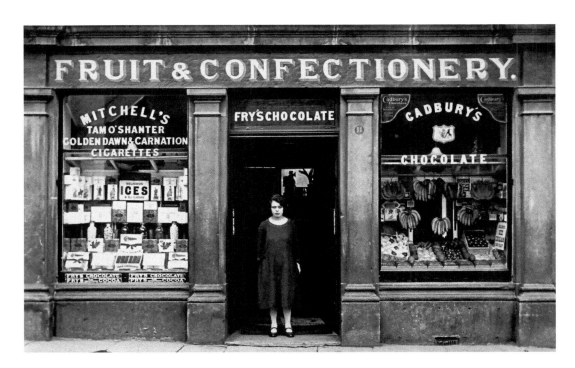

Chapel Street, 1930s and 2015

The lower end of Academy Street becomes Chapel Street, and No. 11 has housed many different business enterprises over the years. Here Cathie Bergamini is pictured at the door of the family shop in the 1930s. Cadbury's and Fry's chocolates were a major part of their produce, and fittingly, the current business is The Chocolate Place, purveyors of home-made Belgian and specialty chocolates, an enterprise run by Debbie Niven and her husband.

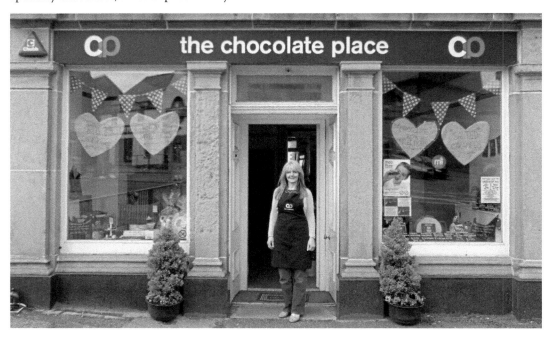

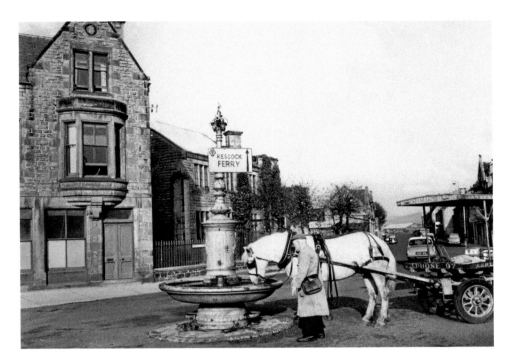

Waterloo Place, 1960s and 2015

Farmer's Dairy milk-float horse using the water basin at the junction of Chapel Street and Waterloo Place. Dubbed the 'fountain' it ended up being damaged by a vehicle and had to be removed. The building to the right once housed the offices of North of Scotland Electric Light and Power Company Ltd, who operated the Inverness Power Station from *c.* 1905 to 1947, when the Burgh generated and ran its own power supply.

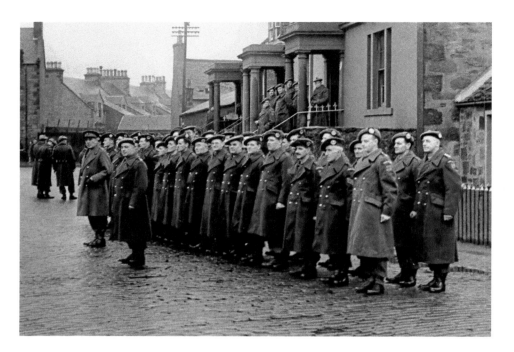

Home Guard Parade at Portland Place, *c.* **1944 and 2015**
The Merkinch platoon of the Home Guard, wearing the badge of the Queen's Own Cameron Highlanders, on parade in Portland Place. The photo was probably taken on the disbandment of the Home Guard a few months before the end of the Second World War, by which time all danger of invasion had passed. Built in 1828, the Portland Club building is one of the oldest existing in Inverness. It was the home of Rangers supporters club Inverness True Blues for many years until 2013 when it became a mosque for the Inverness Masjid Association.

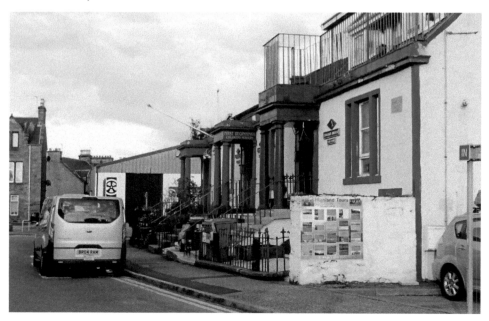

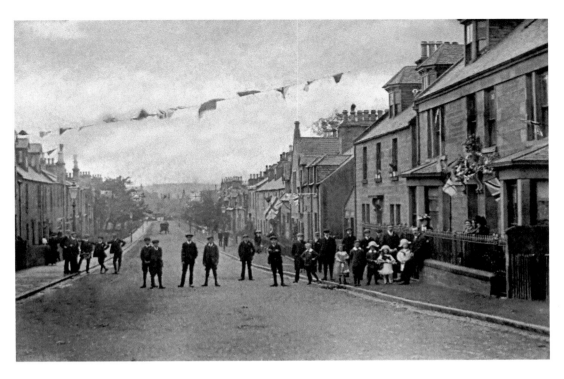

Innes Street, *c.* 1900 and 2014
The homes on the right no longer exist, having been demolished to make way for developments on Longman Road. There now exists a pedestrian underpass where the line of children stand.

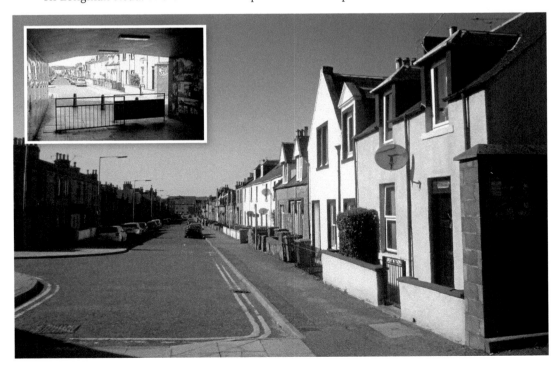

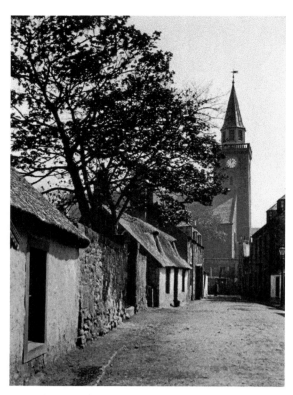

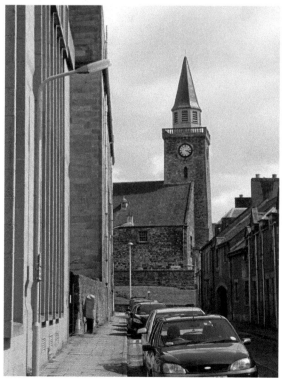

The Old High Church from Friars' Street, *c.* 1920 and 2015
Only the tower remains of the medieval parish church, now surmounted by a parapet from 1769. Jacobite prisoners were confined in the church after the Battle of Culloden and some were executed in the graveyard. It's claimed musket ball marks can still be seen on some of the headstones. Behind the wall on the left is the Greyfriars burying ground and one surviving pillar of the Dominican Friary. The cottages on the left were demolished to make way for the Telephone Exchange.

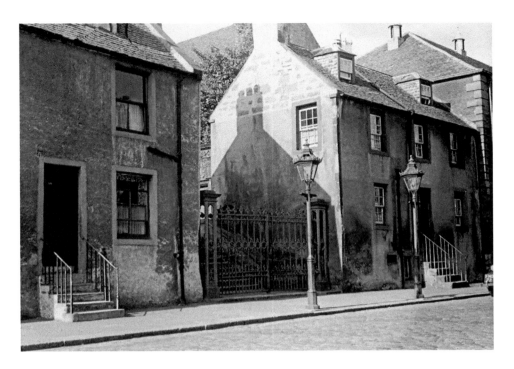

Church Street, 1940s and 2015

Church Street is the oldest street in Inverness, and was at one time the main street. Its importance was due to it being the route between the harbour and the castle and town. The iron gates in the gateway between the two buildings, which leads to the Old High Church, were made at the Falcon Foundry. The Foundry was opened in Academy Street in 1858. At the bottom of Church Street can be seen the Telephone Exchange building.

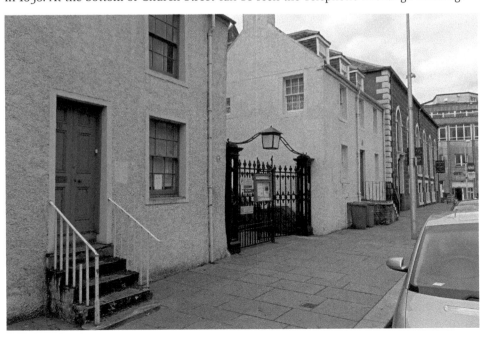

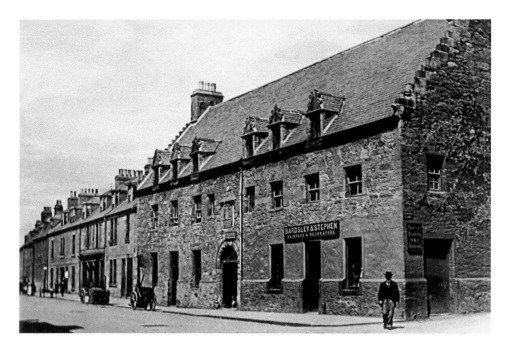

Dunbar's Hospital, Church Street, 1880s and 2015

Built in 1668 and named after Provost Alexander Dunbar. He endowed it as a hospital for the poor and as a Grammar School – which it remained until 1792. The building also served as a poorhouse, cholera hospital, library, fire station and soup kitchen. At one time the town's gallows were stored upstairs. Said to have been built from the materials of Cromwell's Fort, the building has very good decorative dormer heads and crow-stepped gables. It's now occupied by a cafe and senior citizens drop-in centre, with flats above.

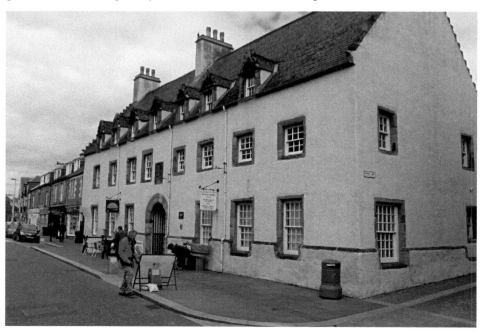

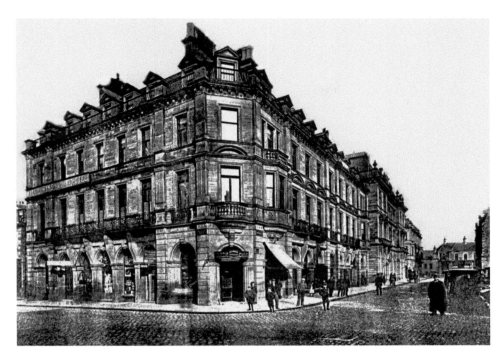

Corner of Church Street and Queensgate, 1890s and 2015

Looking east from Church Street along the then relatively new Queensgate, designed by Alexander Ross and built in the 1880s. In the middle distance is the former post office, erected in 1888 and demolished a mere seventy-eight years later, to make way for a bland glass and concrete structure. In the distance is the old Academy building on Academy Street; now covered by scaffolding since its destruction by fire in April 2015.

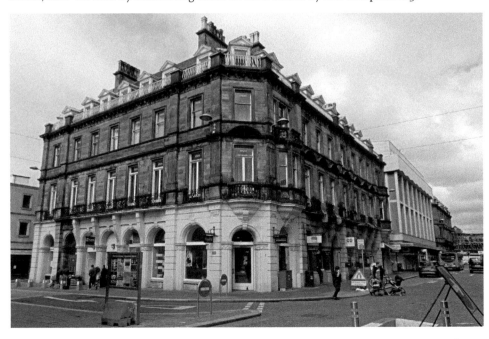

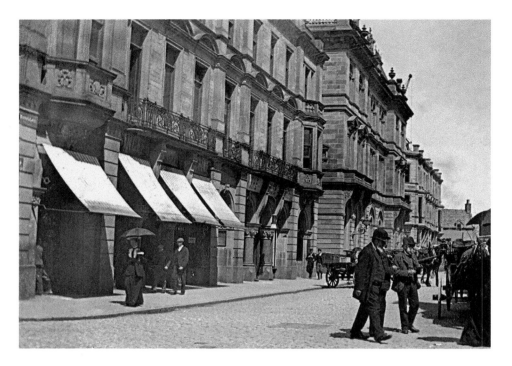

Queensgate, 1890s and 2015

Queensgate runs between Academy Street and Church Street and although laid out by Alexander Ross in 1884 it was not fully developed until 1900. It was to originally have been named Raigmore Street. The post office of 1888, in the centre where the modern building now sits, was demolished in 1966. The original office was a classical building in Italian Renaissance style, all in sandstone and well detailed.

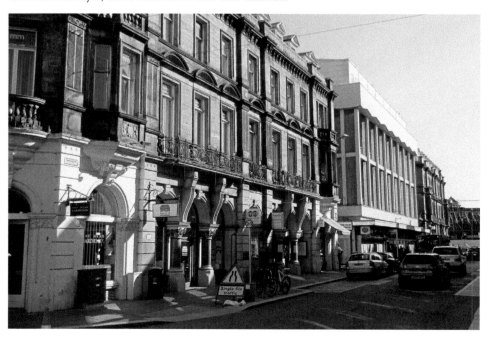

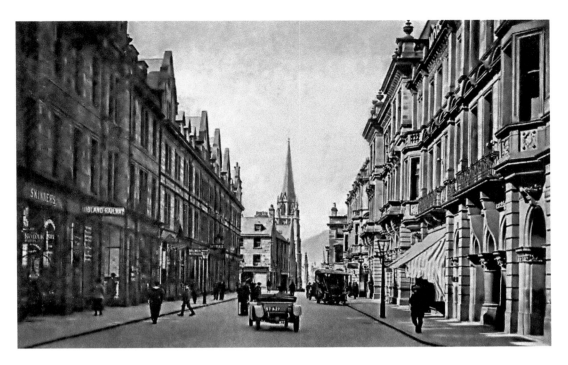

Queensgate, 1920 and 2015

Looking west along Queensgate from Academy Street to the St Columba's Church spire. Home to offices, shops, flats and apartments, it is still the site of the main post office, which was demolished to make way for a modern upgrade. In the same location as the original, with the front the same width and height as before and the same number of windows and doors, one wonders why the original local sandstone was replaced by drab grey concrete facings.

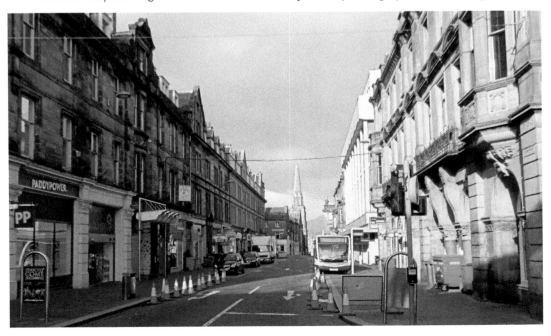

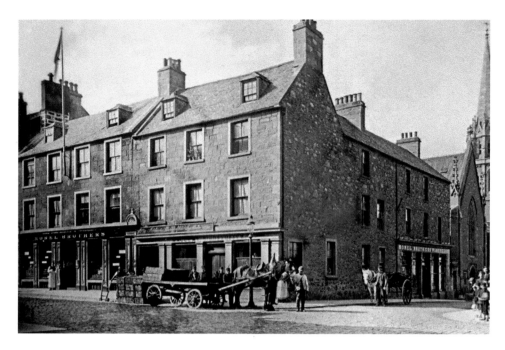

Corner of Church Street and Fraser Street, 1890s and 2015

The Highland gentry were regular customers at both of these premises. Morel Brothers of Piccadilly were Italian wine merchants and ware-housemen who opened their Highland branch to serve the country houses and shooting lodges around Inverness. In 1896, having become 'Purveyors to the Queen and Royal Family', the business moved to Queensgate where they remained until the 1950s. W. A. MacLeay & Son supplied everything a sportsman needed and promoted themselves as the largest taxidermy establishment in Scotland.

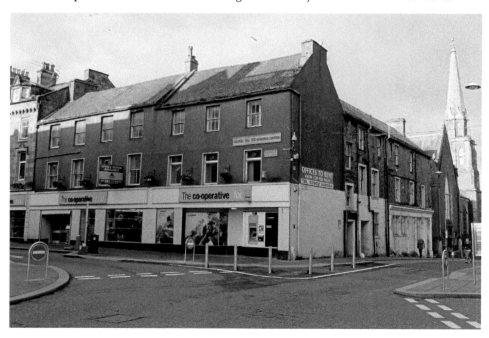

Dalcross's House, Church Street,
c. 1900 and 2014

The house on the corner of Church Street and Queensgate was built in 1700 for merchant James Dunbar of Dalcross. By the 1850s it was occupied by shops. Demolished in 1900 to make way for a new block completing the south side of Queensgate, the new building was occupied by the North of Scotland Bank, later the Clydesdale. The main block, including the Queensgate Hotel, was almost destroyed by fire in 1992 but the bank, at the time a café bar, escaped.

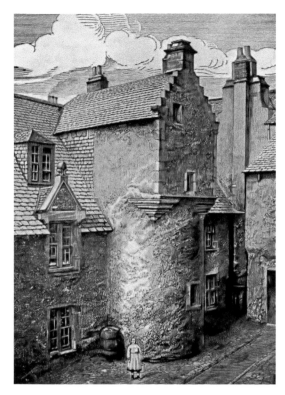

Old Abertarff Close House, Church Street, *c.* **1930 and 2015**
The oldest surviving building in Inverness, this house used to once lie within Abertarff Close. Begun in 1592 as a town house for the Frasers of Lovat with crow-stepped gables (corbie steps) and a stone turnpike staircase, it was for years hidden by the houses in front of it. The building was in a ruinous condition before the houses on the right were removed and it was opened to Church Street. It was restored in 1966 by the National Trust for Scotland.

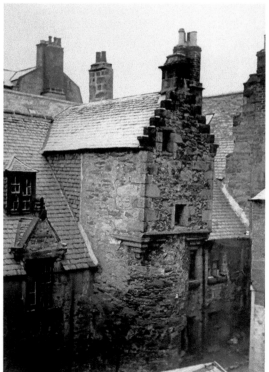

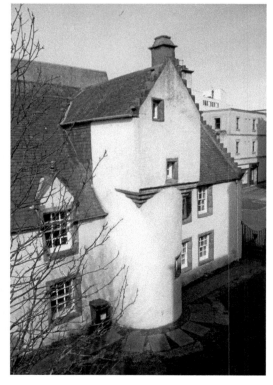

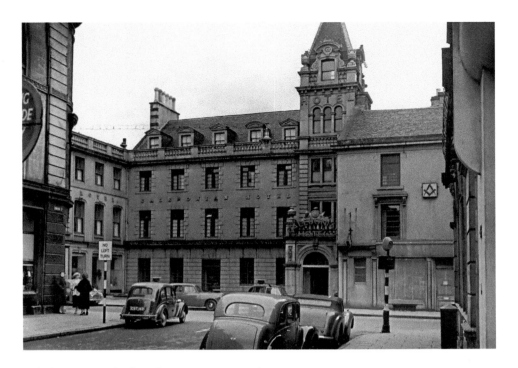

Caledonian Hotel, Church Street, 1950s and 2015

Built in 1780 with money from the forfeited estates as a meeting place for the St John's Masonic Lodge, The Mason's Hotel or the Mason Lodge Hotel fronted both Church Street and Bank Street, with a magnificent outlook over the River Ness. Enlarged in 1822 at a cost of £2,000 it was renamed the Caledonian Hotel in 1825. Enlarged again in 1882 for £6,000, it was renowned for its ballroom. The hotel was demolished in 1966 and replaced by a new building.

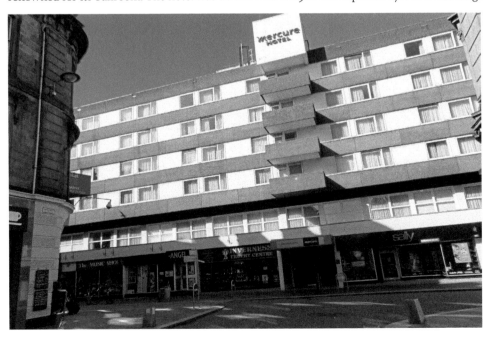

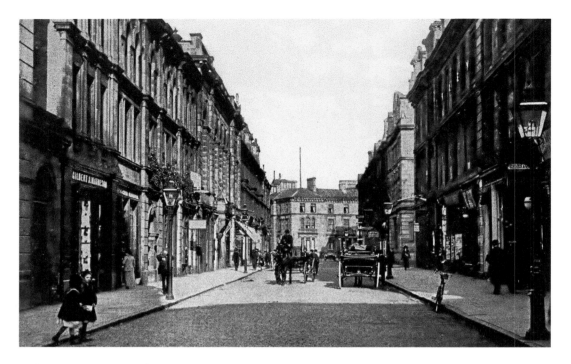

Union Street, 1900s and 2015

Looking east along Union Street to the Station Hotel, now the Royal Highland Hotel in Station Square. Union Street was laid out in 1863 along the line of an older alleyway leading off Church Street. The United Presbyterian Church was located on the corner of Drummond Street until it was demolished in 1900 and re-erected as the Masonic Hall in Alness. The congregation then built the Ness Bank Church.

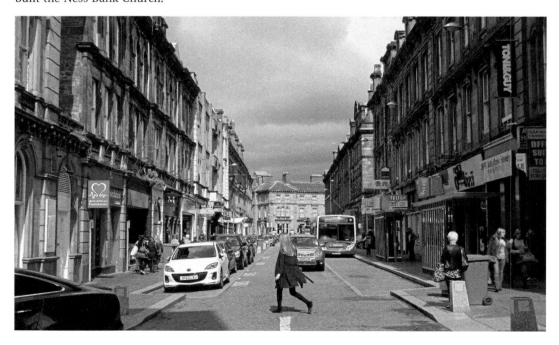

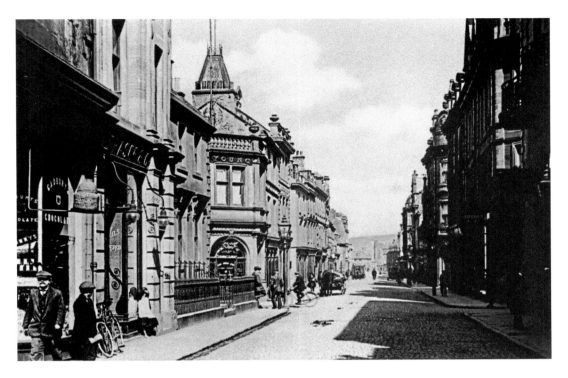

Church Street, 1890s and 2015

Looking north along Church Street from Bridge Street. At the corner of Bank Lane, on the left, are the premises of Young & Chapman, Inverness's first department store, which subsequently moved to larger premises in Union Street. It was later bought over by Benzies.

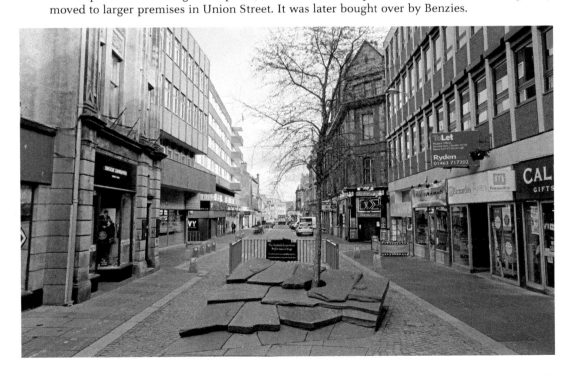

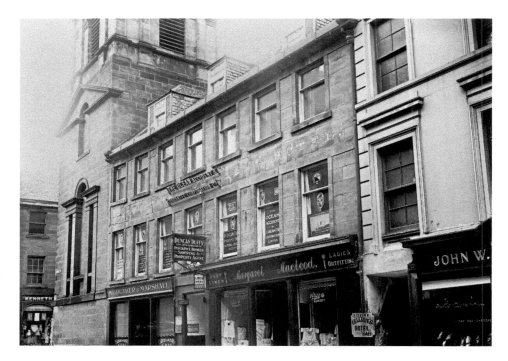

Tollbooth Steeple, Corner of Church Street and Bridge Street, May 1927 and 2014
On the site of the medieval tollbooth is the Burgh steeple built beside the adjoining Old Court House and Jail in 1791 by William Sibbald of Edinburgh, who also designed the spires of St Andrew's Church in Edinburgh. The buildings housing McGruther & Marshall and Margaret Macleod Ladies Outfitters are gone, and the alleyway leading to the back entrance of Gellions Hotel, which is located on Bridge Street, cannot be accessed.

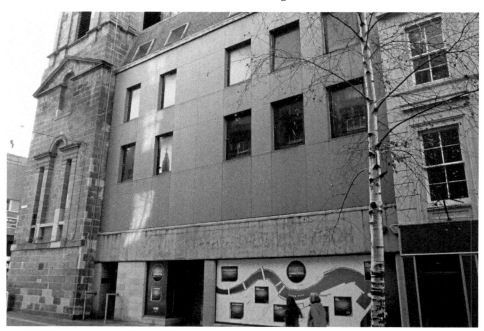

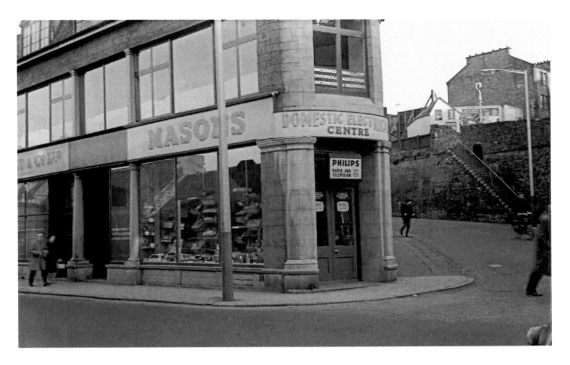

Eastgate Corner, 1950s and 2014

Mason's on Eastgate, the Electromatic Washing Machine Co. Ltd, at the bottom of Crown Road and Old Eastgate. The steps leading to Stephen's Brae are gone, replaced by a curved retaining wall when the area was completely demolished to make way for the Eastgate Shopping Centre development in the early 1980s. The mural, comprising thirty-nine printed metal panels on the 246-foot Crown Road retaining wall which holds up the brae, was erected in 2011.

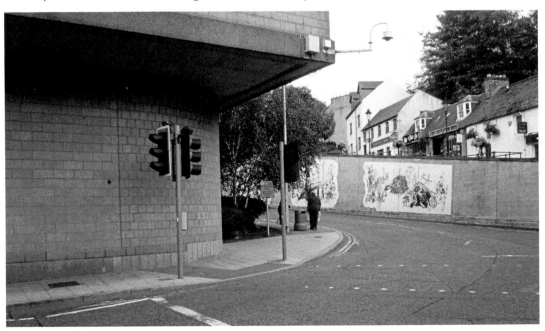

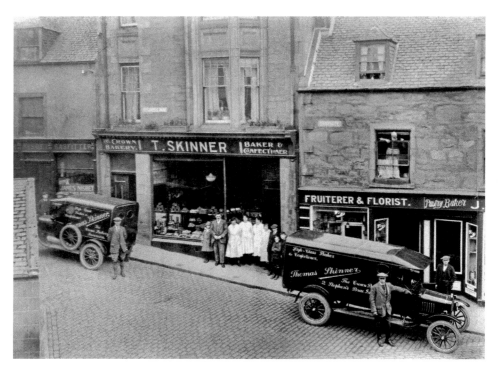

Stephen's Brae, *c.* **1920 and 2015**

Inverness baker Thomas Skinner taking delivery of new Ford Model-T vans. This street, now part-pedestrianised, was the route taken by pupils attending Inverness Royal Academy at Midmills.

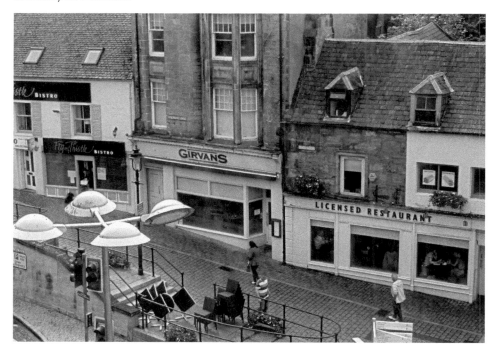

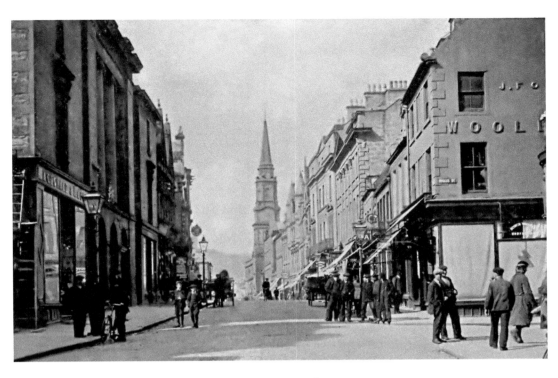

Corner of High Street and Inglis Street, 1890s and 2015
Looking west towards the 148-foot Tollbooth Steeple opposite the Town House. The steps on the left are known as Market Brae or Post Office Steps and the Inglis Street corner on the right is popularly known as 'Boots Corner,' as Boots the Chemists occupied the site between 1898 and 1983.

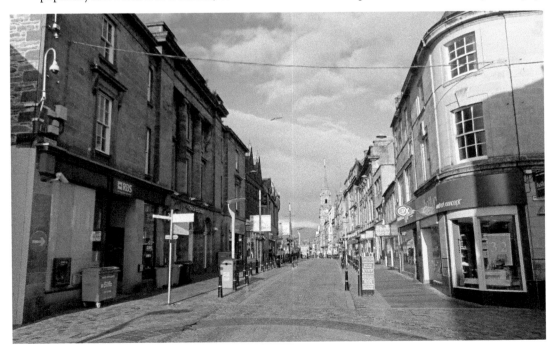

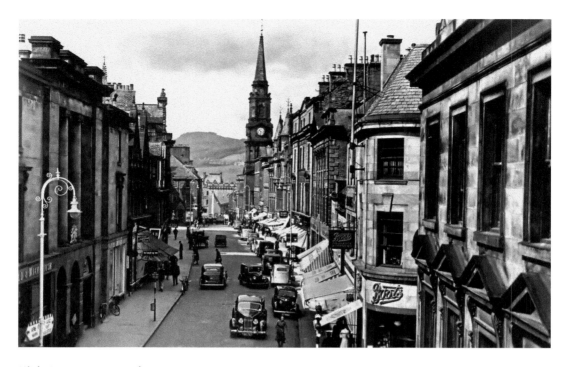

High Street, 1950s and 2015

View west with the castellated tower of the old bridge below the hills of Craig Phadrig. The building from which the 1950s photo was taken was later demolished in the 1970s, along with Hamilton Street and the north side of Eastgate, to make way for the Eastgate Shopping Centre development of the 1980s.

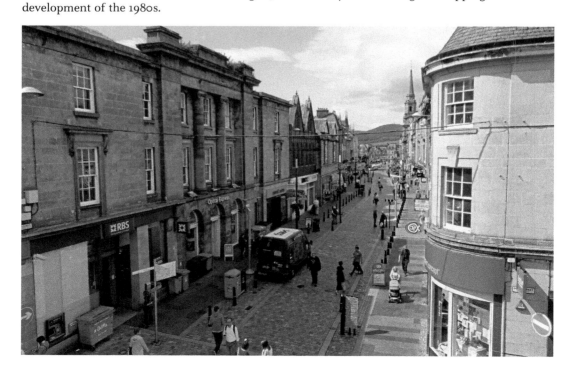

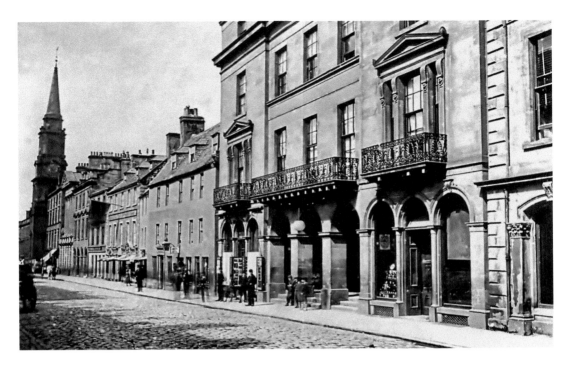

High Street, 1880s and 2015

Looking along High Street, the building now called Eildon House has lost its fancy pillars and archways. Grant's Close, a long-time right-of-way passage leading from the High Street to Baron Taylor's Street was arbitrarily sealed off when the entrance to Metropolitan House was bought by an Edinburgh firm and refurbished in 2011. The reason given was that the Close was 'underutilised'. The town steeple is in the distance.

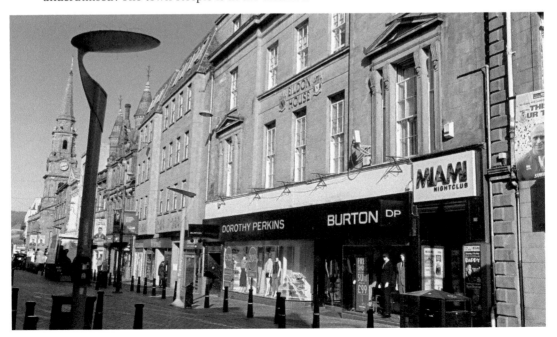

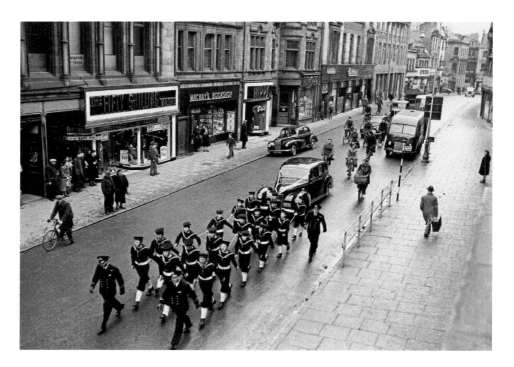

High Street, January 1953 and 2014

Naval bridal procession along High Street, passing the premises of the old Royal Tartan Warehouse (the Fifty Shillings Shop). MacDougall's Royal Tartan Warehouse was established in the 1840s by Donald MacDougall, but rebuilt in 1878–1879 in the ornate and turreted Baronial style that still stands today. The Royal Arms of Scotland are carved on the central panel above the second floor as Queen Victoria and Prince Albert were among his customers.

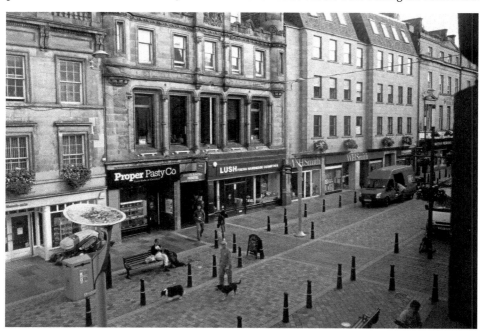

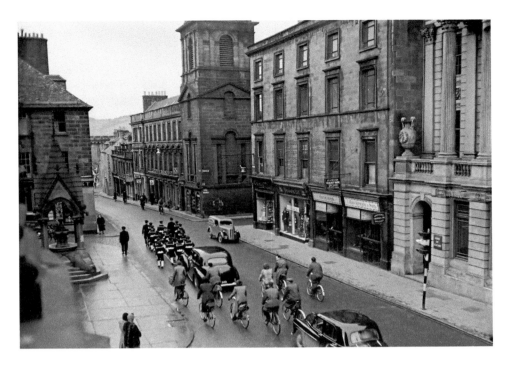

High Street, January 1953 and 2014

The bridal procession continues along the High Street into Bridge Street, passing the Forbes Fountain outside the Town House. The walls at the base of the Tollbooth Steeple on the corner of Bridge Street and Church Street are 5 feet thick, but the upper part of the spire was badly bent in the earthquake of 1816 and had to be rebuilt. The old Court House adjoins the Steeple and a little further beyond is Gellions, the oldest pub in Inverness, established in 1841.

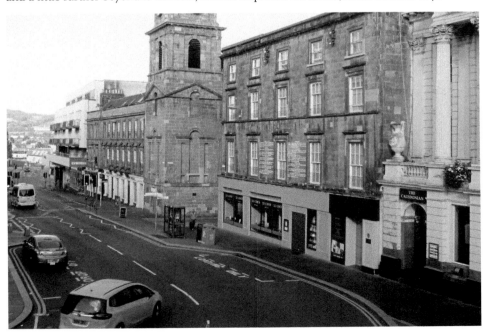

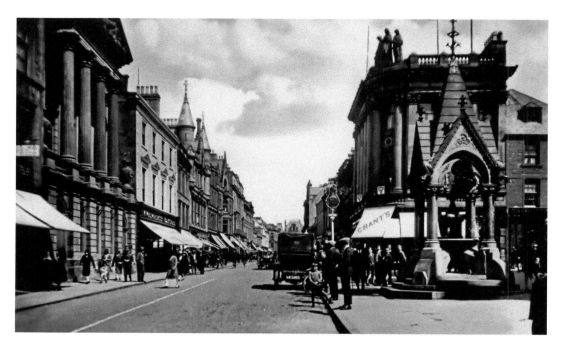

High Street and the Exchange, 1920s and 2015

The building on the left was built in 1848 for the Inverness-based Caledonian Bank. The Forbes Fountain stands outside the Town House in the centre of the original market place, known as the Exchange. Beneath the fountain was the Clach-na-cuddain (the stone of the tubs) where women would rest while carrying home their pails and tubs of water. Now mounted against the wall of the Town House, tradition has it that so long as the stone is preserved Inverness will flourish.

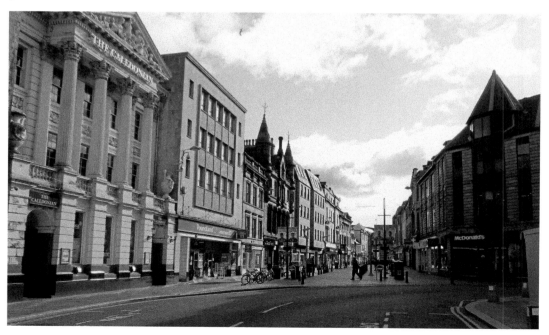

The Three Graces, Corner of Castle Street and High Street, 1950s and 2015
The YMCA and Grant's Warehouse building of 1868 was topped by a group of statuary representing the Three Virtues of Faith, Hope and Charity (known locally as the Three Graces). Each stood about 7 feet tall, the work of local sculptor Andrew Davidson. The statues went into a council depot when the building was demolished in 1955 and later sold to an Orkney antiques collector. They were returned to Inverness in 2007 and erected in the small garden beside Ness Bank church.

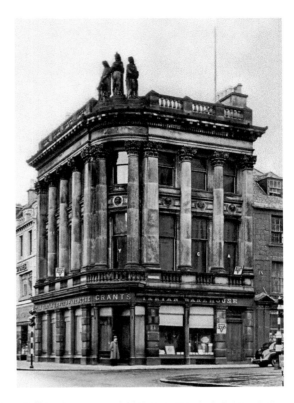

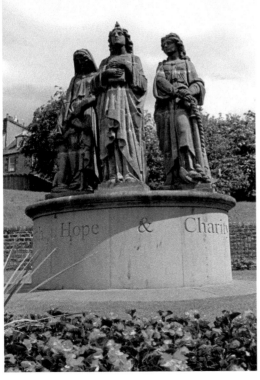

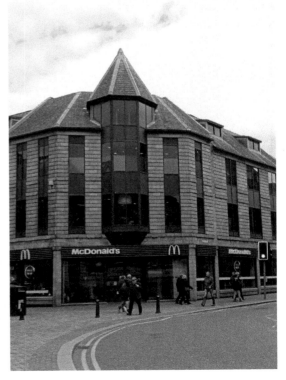

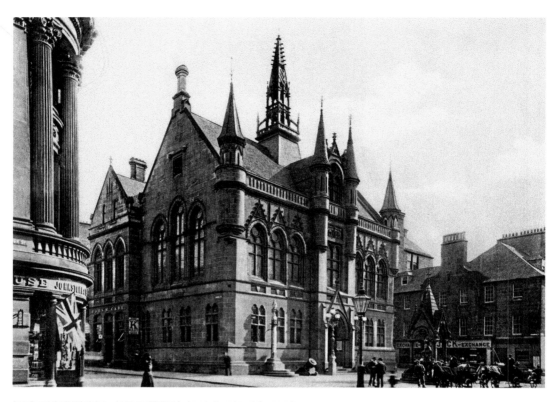

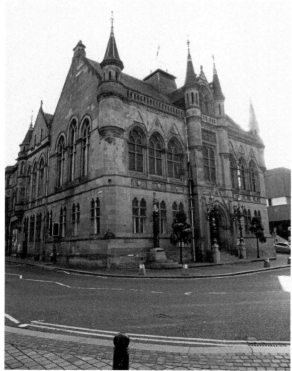

Inverness Town House, Corner of Castle Street and Bridge Street, 1890s and 2015

The Victorian Gothic Town House was built in 1878–1882 at a cost of £13,500. To the left of the entrance stands the old Merkat Cross, probably dating from the sixteenth century. In 1921, Lloyd George held the first ever Cabinet Meeting outside London to discuss the Irish Question in the Council Chamber. The Burgh Arms on the north gable came from the old stone bridge over the River Ness which washed away in the floods of 1849. The building is currently undergoing an extensive programme of refurbishment.

Forbes Fountain, the Exchange, Bridge Street, 1880s and 2015

The fountain was gifted to Inverness in 1880 by Dr George Forbes and erected outside the town house. However, many councillors wanted it removed as it intruded on election meetings and royal visits. They finally got their wish in 1953. The fountain was dismantled, during which the tall ornate granite and metal canopy (two thirds of its height) was 'irreparably damaged.' The base was later re-erected at the end of Ladies Walk beside the River Ness.

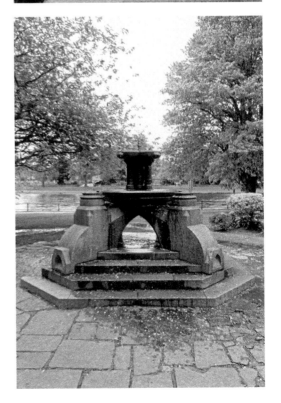

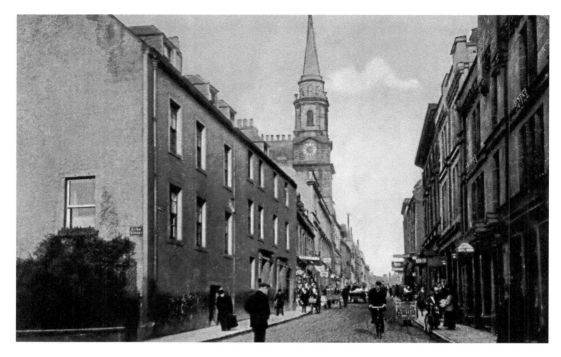

Queen Mary's House, Bridge Street, 1900s and 2015
Built on the site of the house in which Queen Mary is supposed to have stayed in 1562 when she was refused access to the castle by the captain. The interior was very confusing and the staircases led to rooms at various levels in a nightmare fashion. It was demolished in 1968 to make way for the Highlands & Islands Development Board block, with Lows and Littlewoods beneath, and only the medieval vaults remaining of the original structure.

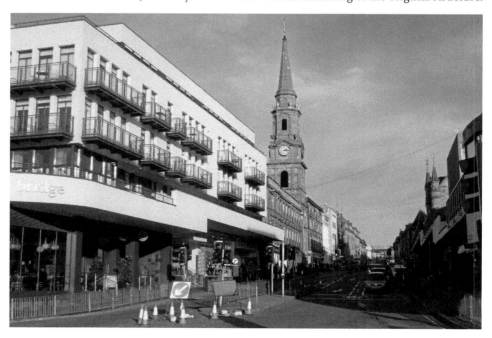

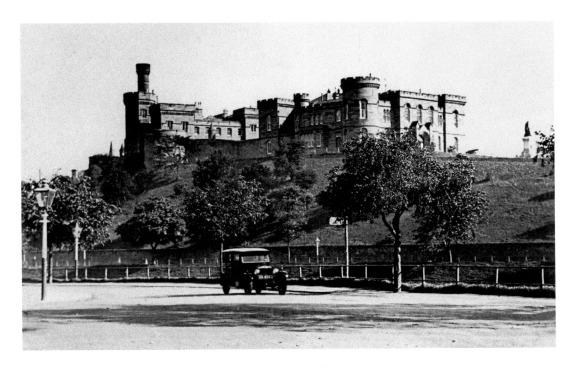

Inverness Castle from Ardross Terrace, 1930s and 2015

There's been a castle on the hill since 1057 when Malcolm Canmore replaced MacBeth's castle which he had destroyed. The first stone castle was built during the reign of King David (1124–1153) and in 1412 it was rebuilt by the Earl of Mar. In 1427 James I visited the castle and summoned the Highland Chiefs. Three were executed and others imprisoned for disobedience to his authority. In 1429 the Lord of the Isles burned Inverness, but the castle held out.

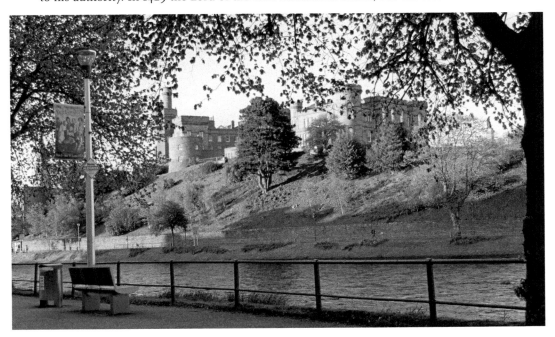

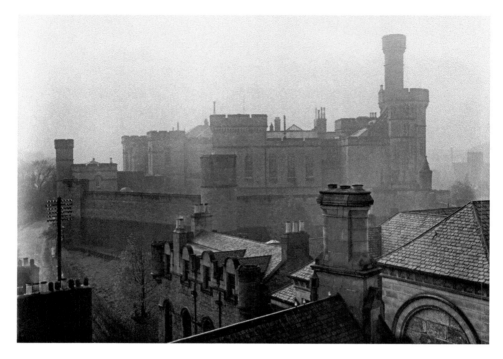

Inverness Castle, Before and After Renovations, April 1934 and 2014

A tower house was added by the Earl of Huntly in 1548. Mary Queen of Scots visited Inverness in 1562 but the castle captain wouldn't permit her to enter while the governor was away. When later allowed in with her retinue Mary had the captain executed and his head exhibited on the castle wall. The castle became neglected and suffered from its occupation by the clans in 1639. The doors, gates and windows were broken up and the furnishings and library of books spoiled.

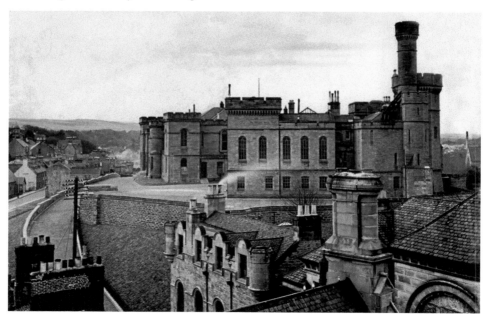

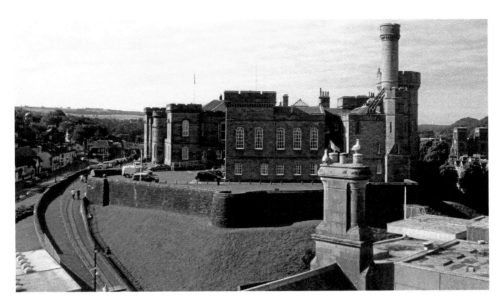

During the civil war in 1649 it fell to the Royalist forces. In the 1715 Jacobite rising the castle was briefly held by the Jacobites, but soon recaptured by Hanoverian troops. Renamed Fort George it was enlarged and strengthened and by 1725 it contained barracks for 800 soldiers.

In the 1745 rising Bonnie Prince Charlie took the castle and had it blown up with explosives. The French sergeant who lit the fuse was killed and his dog was blown across the river but escaped with the loss of his tail. The castle lay in ruins until 1833. It had become a quarry for builders; one stone said to have come from the castle was built into the front garden wall of a house in Culduthel Road – it has a large 'V' and the date 1620.

In 1833–1836 the south block of the present castle was built to a design by William Burn, to house the Sheriff Court. The northern section, designed by Thomas Brown, was built in 1846–1848. The walling was designed by civil engineer Joseph Mitchell. The soft red sandstone of the building has severely deteriorated over the years from its exposure to the elements on the elevated ground.

The comparison photos from 1934 were taken from the roof of the town house and show the result of the renovations to the outer walls, which lowered them considerably, and the removal of the gatehouse entrance.

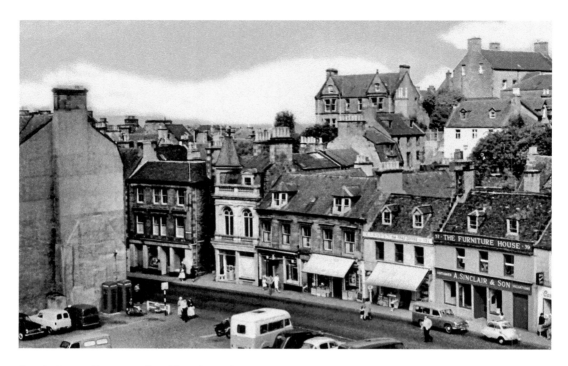

Castle Street from Castle Hill, 1961 and 2015

The profile of the hillside beneath the castle was altered by the October 1932 landslide which destroyed part of the wall built by General Wade. The collapse destroyed buildings where the car park is now and the outline of one of the houses can still be clearly seen on the outer wall of the Council building. The castle still houses the Sheriff Court but there are proposals to relocate it so a better use can be found for the castle.

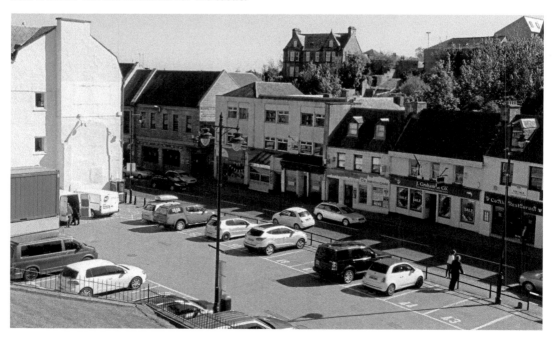

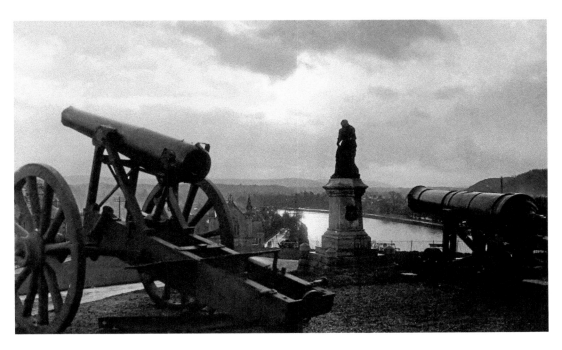

Flora Macdonald Statue, Castle Hill, 1930s and 2015
Artillery guns and Flora Macdonald statue overlooking the River Ness from Castle Hill. Flora helped Bonnie Prince Charlie escape after the Jacobite Rebellion failure in 1746. The statue was unveiled in July 1899. On the left is an 1873 German cannon captured by the Cameron Highlanders in the First World War. The cannon on the right was a trophy from Sebastopol in the Crimean War, presented to Inverness in 1857. It sits on a cast metal carriage built by the Rose Street Foundry.

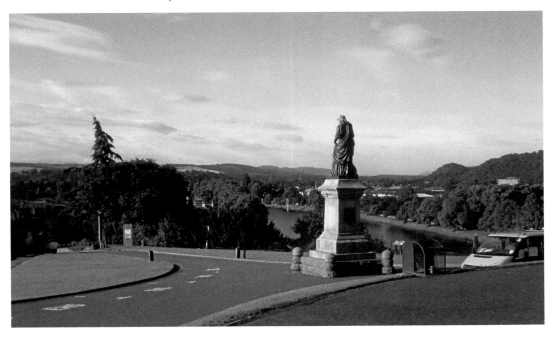

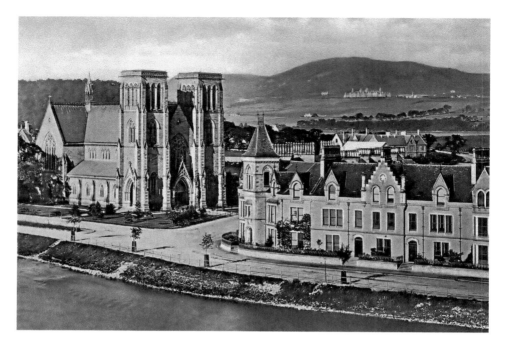

St Andrew's Cathedral from Castle Hill, *c.* 1900 and 2015

Inverness Cathedral was built to a design by Alexander Ross in Gothic Revival style. Bishop Eden decided to move the seat of the diocese from Elgin to Inverness and the foundation stone of the new Episcopal cathedral, the first in Britain since the Reformation, was laid in 1866. The buildings on Ardross Terrace were also designed by Ross, and followed the cathedral in 1873–1874. On the hill in the distance can be seen Craig Dunain Hospital.

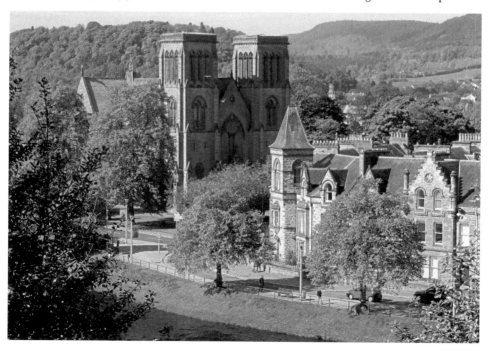

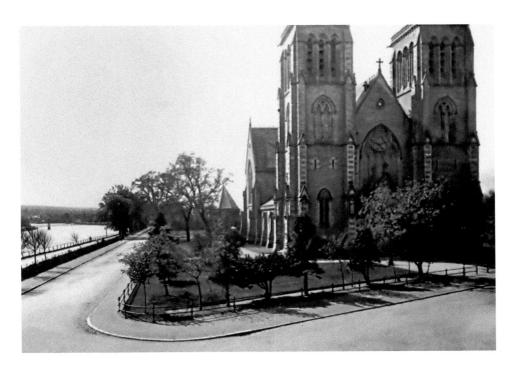

St Andrew's Cathedral, Corner of Ardross Street and Bishop's Road, *c.* **1910 and 2015**
The towers are 100 feet high and the original plans envisaged two giant spires rising a further 100 feet from the top of each tower, but the funds were not available. The cathedral was dedicated in 1869 and consecrated in 1874. Built of red Tarradale stone, the nave columns are made from Peterhead granite and the choir stalls from Austrian oak. The altar and the reredos, the carved screen behind the altar, are made from stone imported from Caen.

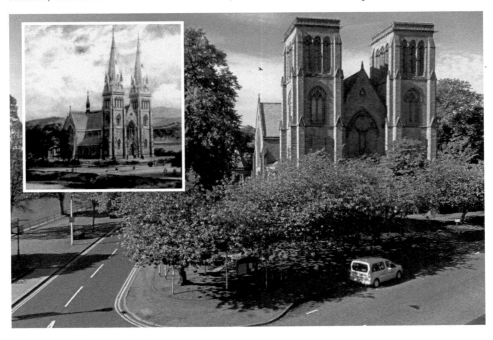

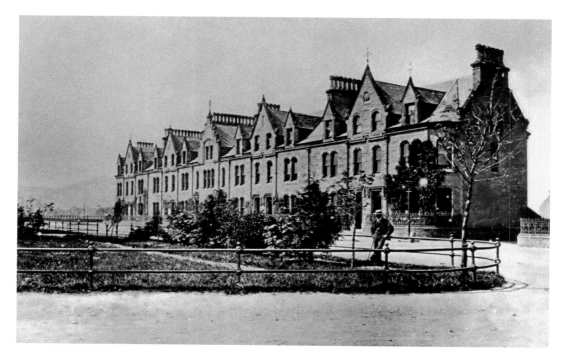

Ardross Street, *c.* 1910 and 2015

The Northern Meeting Park is located on Ardross Street, next to the cathedral. This row of buildings opposite the cathedral were built during the 1880s. The lane on the right, now Alexander Place, was originally called Tanner's Lane and the faint vintage signage is still visible on the gables.

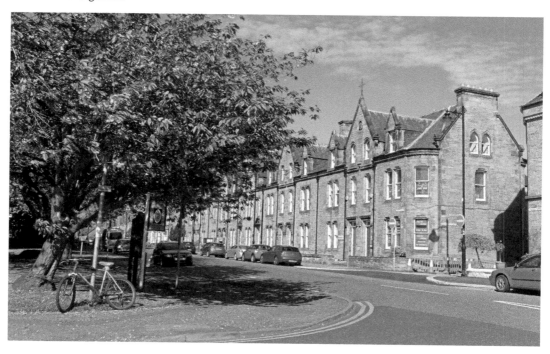

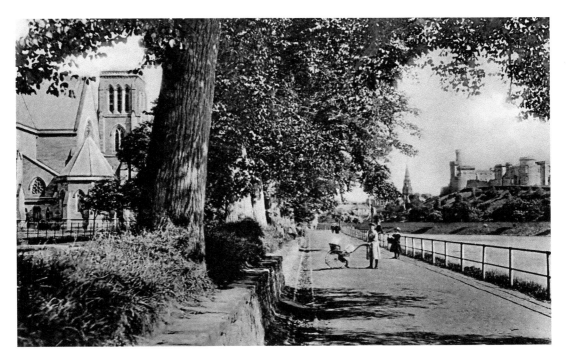

Ness Walk, *c.* **1900 and 2015**

The west bank of the river at the turn of the twentieth century was a cobbled walkway known as Ness Walk. The wall and trees have since been replaced by the road. On the left is the cathedral while on the right is the castle and Town Steeple.

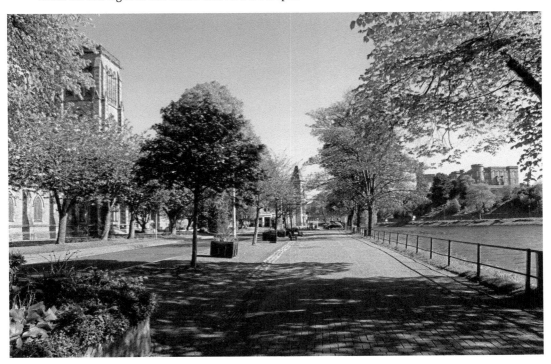

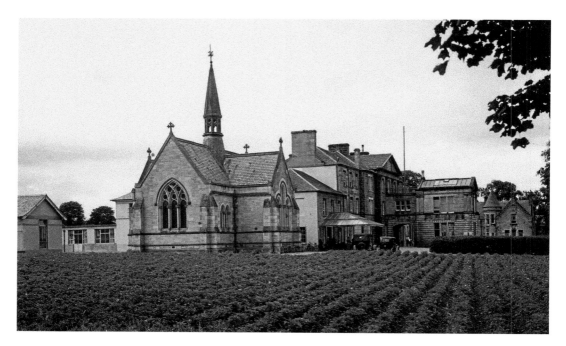

Royal Northern Infirmary, Ness Walk, *c.* **1930 and 2015**

Founded in the eighteenth century, the Royal Northern Infirmary has been enlarged several times. The side pavilions were heightened to three storeys in the 1860s. The central project block, with the operating theatre housed above it, and the Tweedmouth Memorial Chapel were all added between 1896 and 1898. Repairs were again needed in 1928. Opened by the Duke and Duchess of York in May 1929, the children's ward was named The Princess Elizabeth of York Ward after their daughter, the future Queen Elizabeth II.

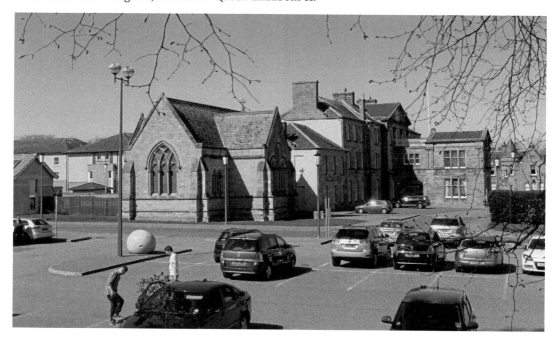

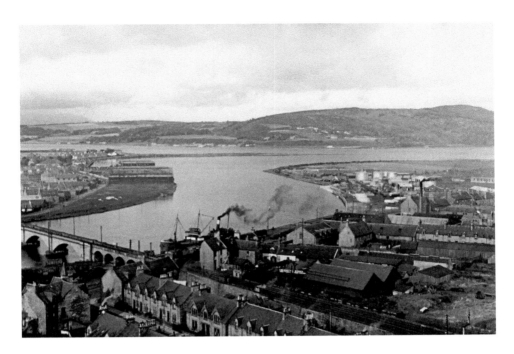

Mouth of the River Ness and the Harbour, 1930s and 2015

The Port of Inverness at the mouth of the River Ness is one of Scotland's most sheltered and deep natural ports. First recorded in 1249, it is owned and operated by Inverness Harbour Trust, established by Act of Parliament in 1847. The railway bridge is the only rail connection to the north of Scotland. The original bridge, a series of five stone arches, was built in 1862 but collapsed during flooding in February 1989. The row of houses is on Innes Street.

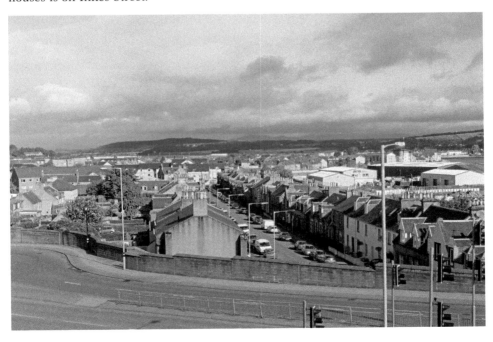

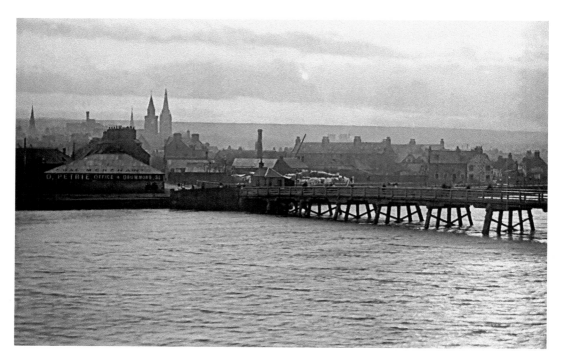

Waterloo Bridge (Black Bridge), *c.* 1890 and 2015

A bridge has spanned the River Ness for 1,000 years. In 1410 the Lord of the Isles destroyed Inverness and burned an oak bridge, described as being one of the finest in all Scotland. The first stone bridge of 1689 was washed away in the Great Flood of 1849. A wooden bridge built in 1808 was called the Black Bridge due to the staining of its wooden timbers. It was replaced in 1896 by the current Waterloo Bridge, but is still referred to as the Black Bridge.

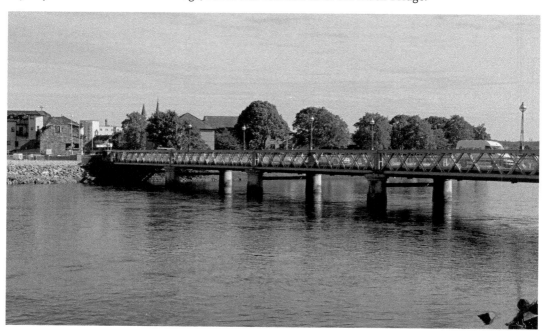

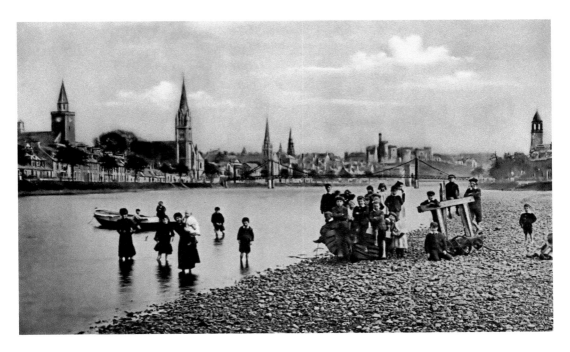

Inverness Townscape from Friars Shott, *c.* **1900 and 2015**

The stretch of water opposite Huntly Street is known as Friars Shott. The Dominican friars, established around 1233, owned the fishing in this pool in the River Ness. On the left is the Old High church and to its right the Free North church, erected 1889–1893. Decorated in Gothic style it has the highest steeple in Inverness and dominates the river. Further right is the Free High Church, now St Columba's, and the Tolbooth Steeple. On the opposite bank is the former Queen Street church steeple.

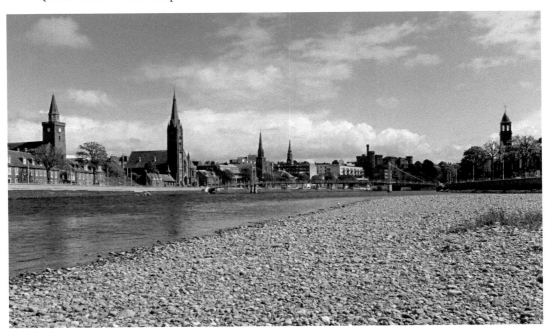

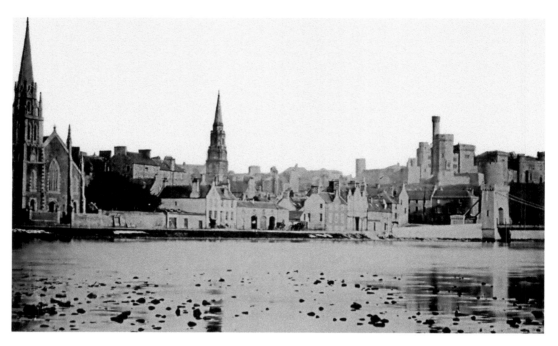

Inverness Townscape across the River Ness, 1856 and c. 1890

One of the earliest photographs of Inverness, only seven years after the Great Flood washed away the 170 year old stone bridge. The washerwomen of Inverness had a ready-made bleaching green in the grassy slopes of the river bank. St Columba's High church on the left opened in 1852 but a fire on 27 May 1940 left only the walls and steeple standing. Rebuilding began in January 1947 by the congregation, servicemen and POWs. It was re-dedicated in September 1948.

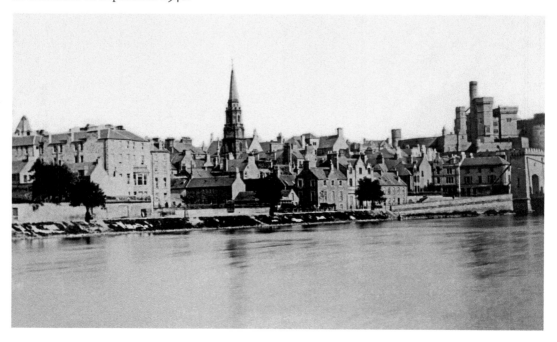

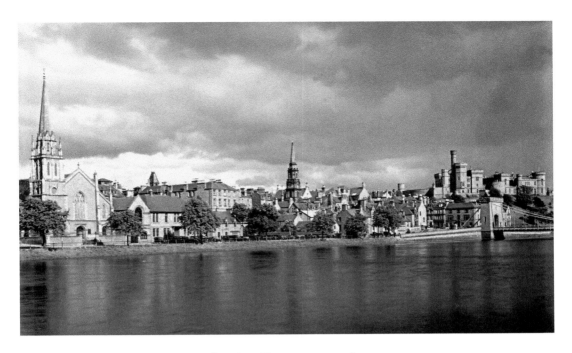

Inverness Townscape across the River Ness, *c.* 1930 and 2015

The skyline of the town gave way to the architecture of the 1960s. The suspension bridge and surrounding buildings were the first to be demolished, followed by the Caledonian Hotel. Among the buildings deemed most offensive are the former offices of Highlands and Islands Enterprise, which has since been turned into luxury flats, and the empty Crofters Commission buildings overlooking Bridge Street. Author Bill Bryson described them as 'two sensationally ugly modern office buildings that blot the town centre beyond any hope of redemption.'

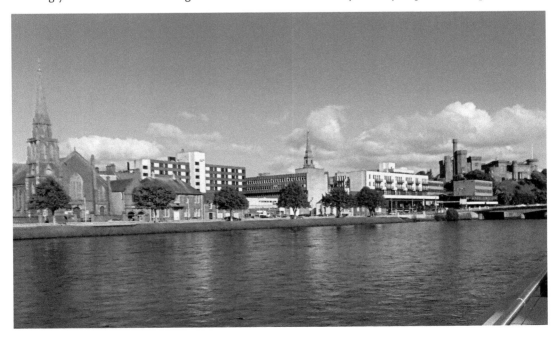

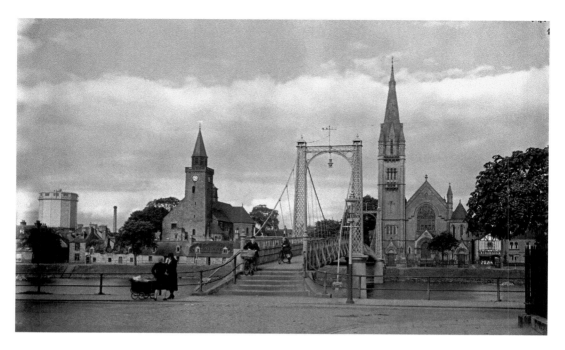

Greig Street Bridge, *c.* **1930 and 2015**

One of two suspension footbridges built across the River Ness in 1881, the Greig Street bridge used the then-new technique of wire-rope suspension cables. At the time there were only two road bridges over the Ness, so they were welcomed by pedestrians. The bridge was built by the Rose Street Foundry, whose premises were nearby. The cottages below the Old High Church were demolished in the 1970s. Gas was first introduced to Inverness in 1826 and this gas works was demolished in 1966.

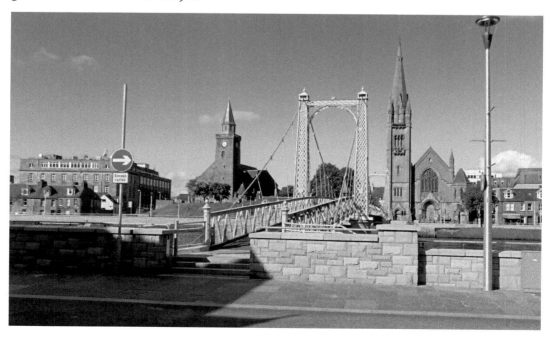

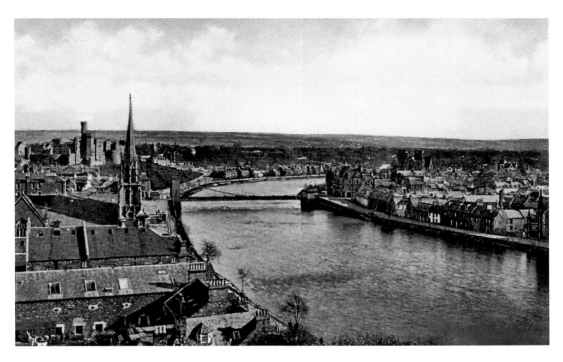

View Upriver from the Old High Church Steeple, 1880s and 2015

This view south takes in the spire of St Columba's church, Inverness Castle, the Ness Bridge and St Andrew's Cathedral. The vintage photograph was taken before the Free North church was erected in 1893 on Bank Street, at a cost of around £10,000.

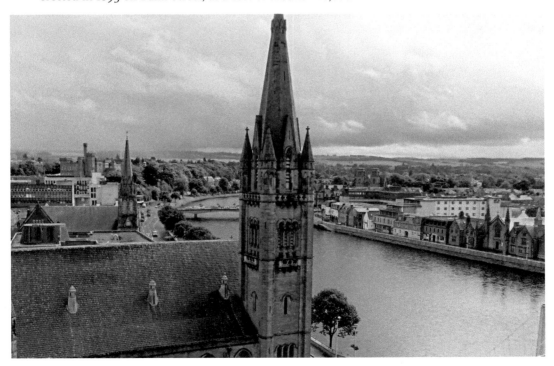

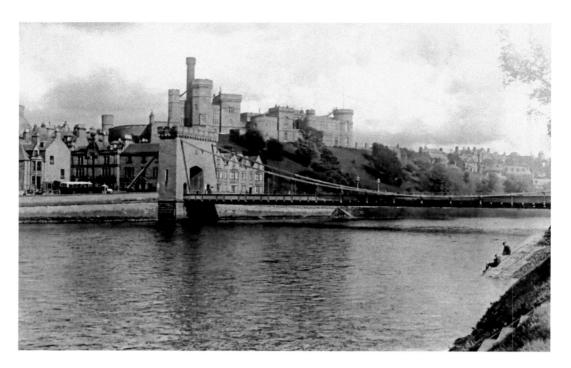

Ness Bridge, 1930s and 2015

The town's first suspension crossing had a battlemented archway at the Bridge Street end and two smaller towers at the Young Street end. The castellated design of the archway was designed by James Rendel to complement the castle on the hill above. Work began in 1852 and required the pulling down of Castle Tolmie, a house on the corner of Bridge Street and Bank Street dating from 1678. The bridge opened in 1855 and was hailed as a superb portal into Inverness.

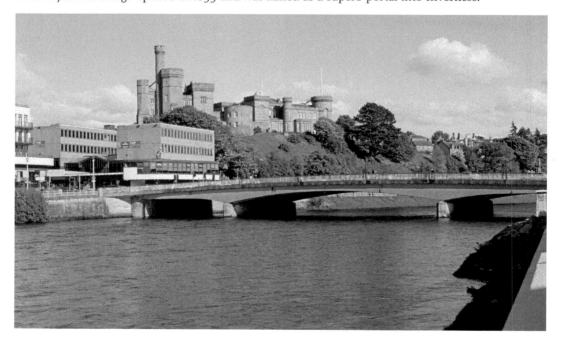

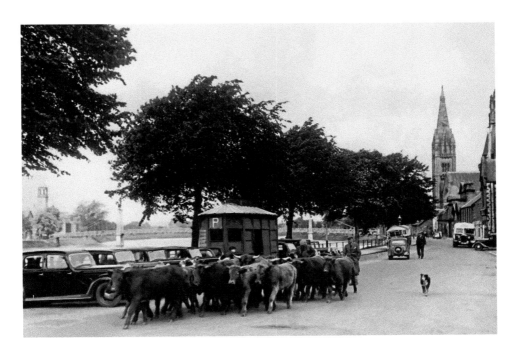

Bank Street, 1930s and 2015

Cattle being herded by the taxi rank on Bank Street beside the River Ness, on their way to market. By the 1890s, ordinary markets were held in Inverness every Tuesday and Friday while livestock markets were held on Fridays following the formerly important Muir of Ord markets. Inverness became an important centre for the sale of stock, while Muir of Ord decreased in importance. Today, the Highlands' main mart has returned to Ross-shire, in Dingwall, while the Inverness marts are long gone.

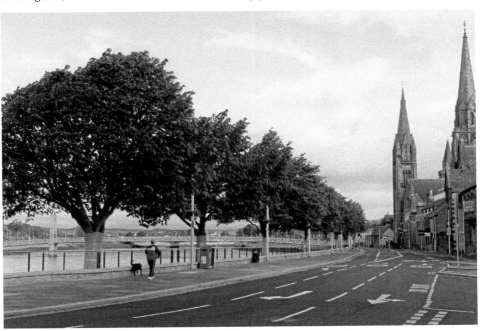

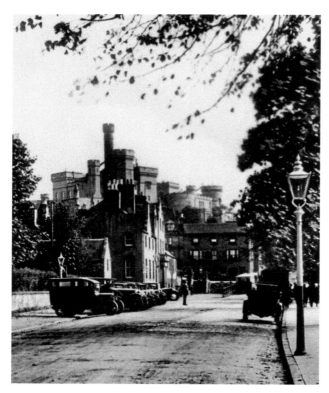

Bank Street, *c.* **1930s and 2015**
Bank Street beside the River Ness. *The Inverness Courier* building was erected in 1804 and first occupied by the newspaper in 1838. The 'parking stance' has long gone, and the buildings on the corner of Bridge Street and Castle Road were demolished in the late 1950s in preparation for the new bridge building works.

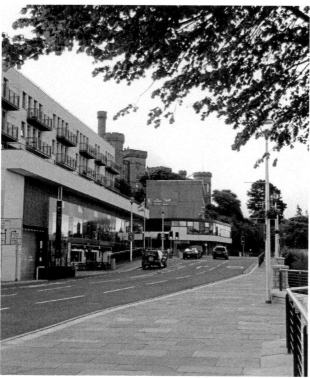

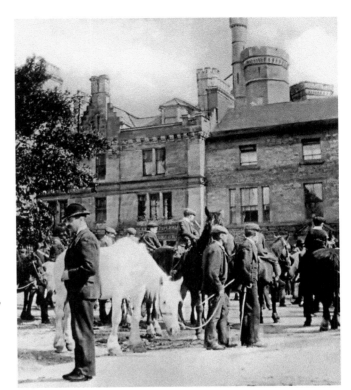

A Horse Fair Below the Castle, 1920s and 2015

All of the original buildings on the south side of Bridge Street have been demolished. Formerly known as Brig Gait the south side of the street once housed the Ettles Hotel, visited by Robert Burns and his schoolteacher companion Willie Nicol on his third tour of Scotland in 1787. Other buildings included the County Hotel, the Workman's Club and the Cairngorm House shop.

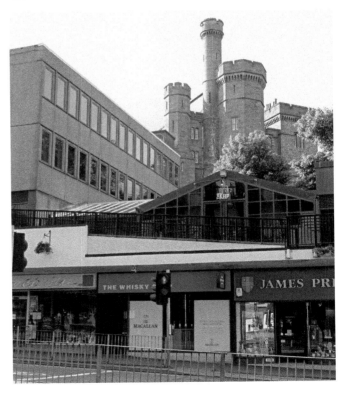

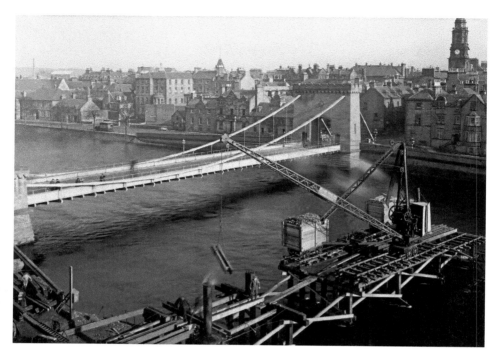

Building the Temporary Bridge, July–August 1939 and 2015

The view from Room 204 of the Columba Hotel. By the 1930s a replacement bridge over the river was needed because of the proliferation of motor vehicles. The building of a temporary bridge was erected by the contractor to enable traffic to cross while the new bridge was being built. The tender for the new bridge came in at £250,000.

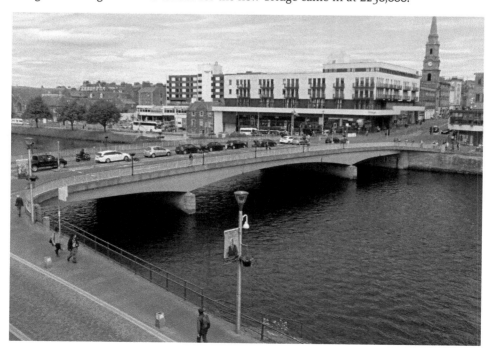

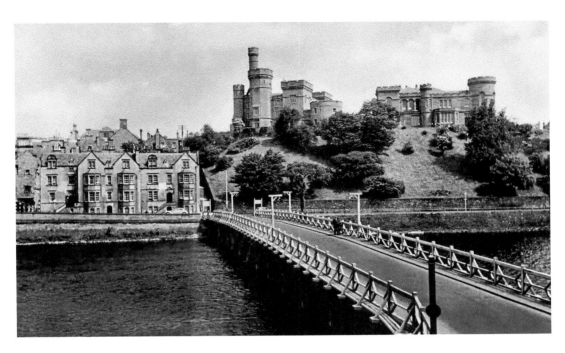

The Temporary Bridge and Inverness Castle, 1950s and 2015

A speed limit of 10 mph was imposed on the temporary bridge, but demolition of the Ness Bridge was cancelled in 1939 with the outbreak of the Second World War. Vehicles then travelled one way over each of the two bridges for the next twenty years. The old bridge was eventually closed in September 1959 and demolished. The New Bridge opened to traffic in August 1961. The older part of the castle (1834) is on the right, the later part (1846) on the left.

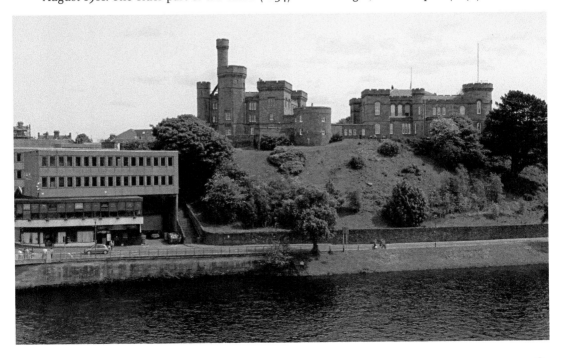

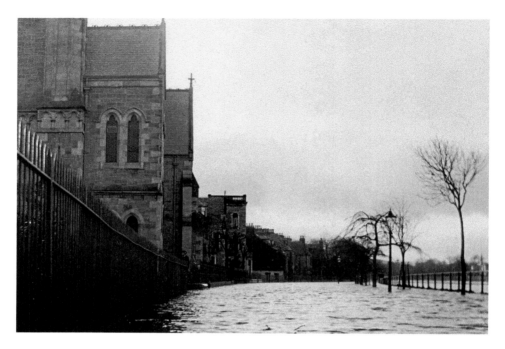

Flooding near Ness Bank Church, 1950s and 2015

The Ness Bank church was designed by William Mackintosh and built in 1900–1901 on a steeply sloping site. The church hall and other accommodation lies beneath the building, which caused many problems during flooding. The River Ness breaks its banks quite often, especially when high tides, westerly winds and a heavy rainfall in the mountains combine.

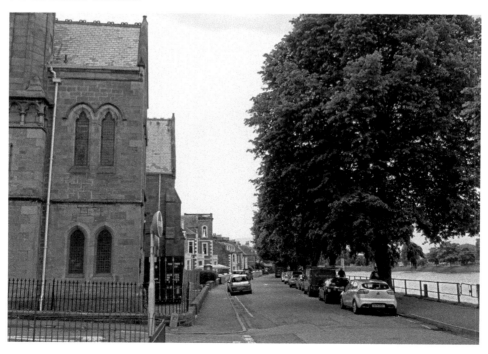

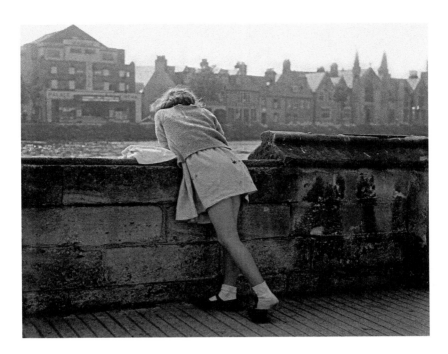

Huntly Street on the River Ness from Bank Street, 1950s and 2015
The above image form the Jimmy Nairn Collection shows the old Palace Cinema across the river in Huntly Street, which opened in 1938. At far right is St Mary's Roman Catholic church, the first Catholic church to be built in Inverness, which opened in April 1837. The new £25 million flood work defence scheme, causing two years of disruption, was finished in 2015 and will protect up to 800 homes and 200 businesses from future flooding.

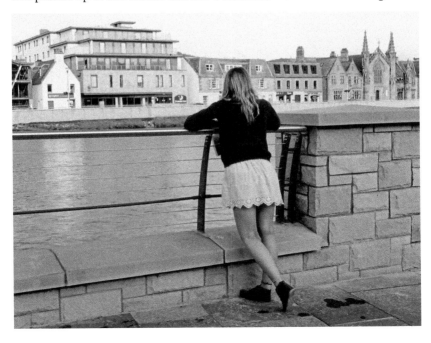

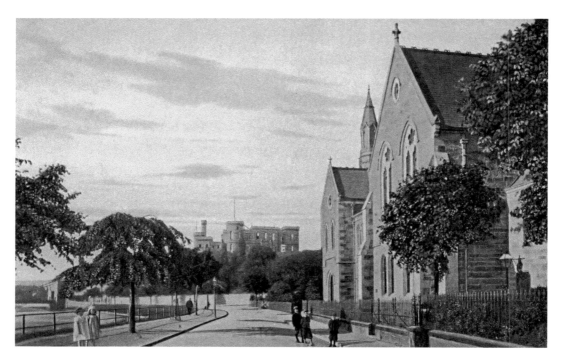

Ness Bank Church, 1900s and 2015

The Ness Bank church congregation originally belonged to the United Free Church which joined with the Church of Scotland in 1929. Built in early Gothic revival style in red sandstone with freestone dressings in 1901, the church seats 700 people. The small garden at the junction of Ness Bank and Castle Road is where the Three Graces statue from the old YMCA building is now located.

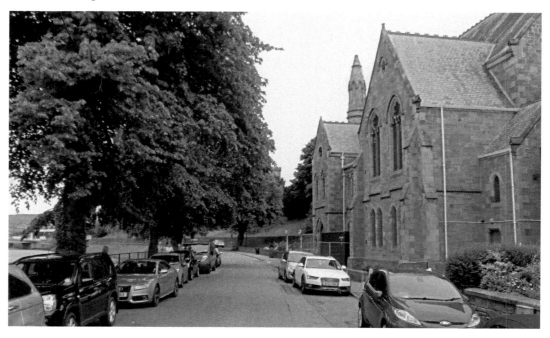

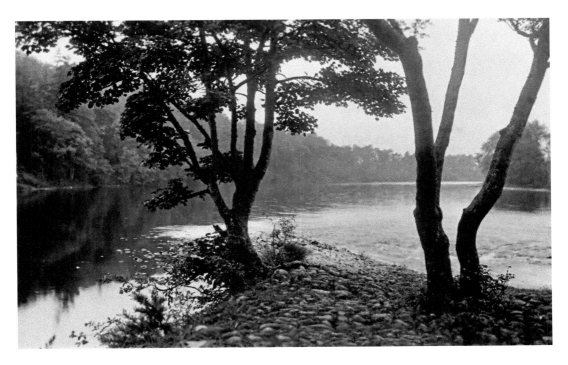

Ness Islands, 1920s and 2014

Situated on the River Ness opposite Bught Park, the first bridges to the islands were built in 1828. Before their construction the only access was by boat. The original bridges were washed away in the flood of 1849 and replaced in 1853–1854 by two suspension bridges. The islands are home to a number of imported species of trees, and wildlife such as bats, otters and deer. They are a natural beauty spot and a popular walk with both tourists and locals.

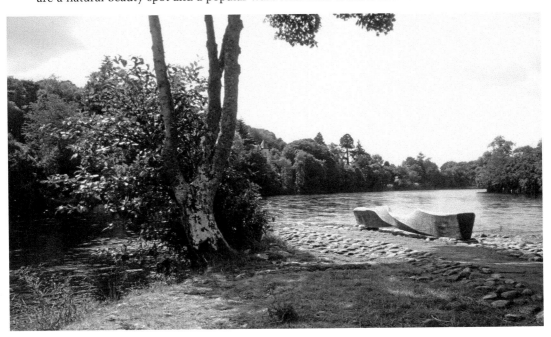

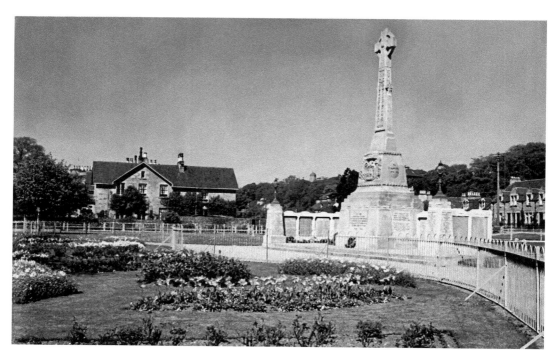

War Memorial, Cavell Gardens, Ness Bank, 1930s and 2014
Set in Cavell Gardens at the end of Ness Bank, the War Memorial was unveiled in December 1922 before a crowd of 5,000 people, and now commemorates the dead of both world wars and subsequent conflicts. The red sandstone Celtic cross was designed by John Hinton Gall and stands 33 feet high. The gardens were named after Edith Cavell, a nurse who helped allied soldiers cross the Dutch border during the First World War. She was executed by the Germans in 1915.

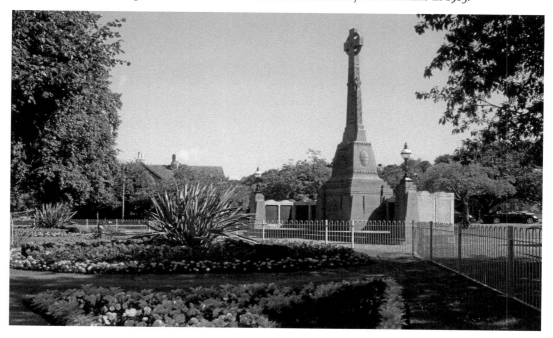

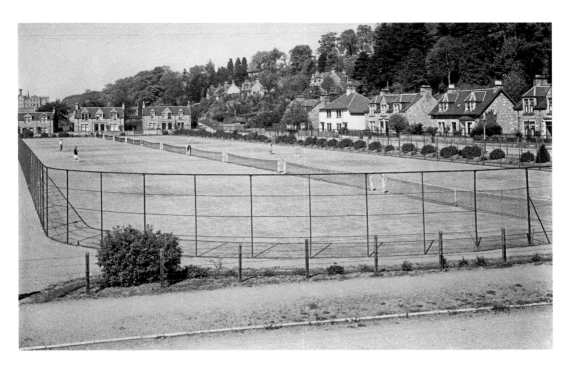

Tennis Courts at Bellfield Park, *c.* 1938 and 2014

Bellfield Public Park is situated along Haugh Road. Within the boundary are a pavilion and small bandstand, tennis courts, putting greens and a children's playground and paddling pool. Inverness Provost Petrie opened the Bellfield Park Recreational Grounds in May 1924. The public tennis grounds consist of ten courts and when first opened had provision for refreshments at the ground. The fee for playing tennis there was 6*d* for 40 minutes.

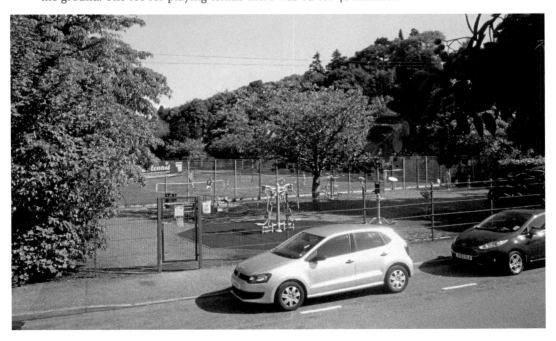

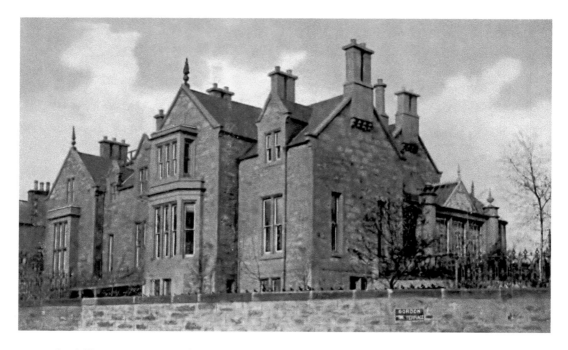

Viewhill House, 1920s and 2015

Once the home of nineteenth-century civil engineer Joseph Mitchell, Viewhill House is a B-listed mansion on the corner of Old Edinburgh Road and Castle Street. Mitchell was a pioneer of the Highland Railways and inspector of roads and bridges. He has been mentioned several times throughout these pages. Viewhill was designed by Mitchell and built in 1839. It has been a home, a maternity unit, a youth hostel and a boarding school over the years, but has been derelict since a suspicious fire in 2007.

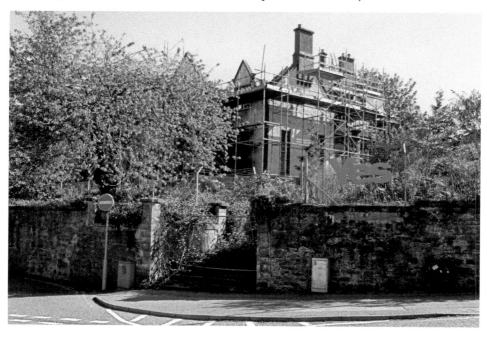

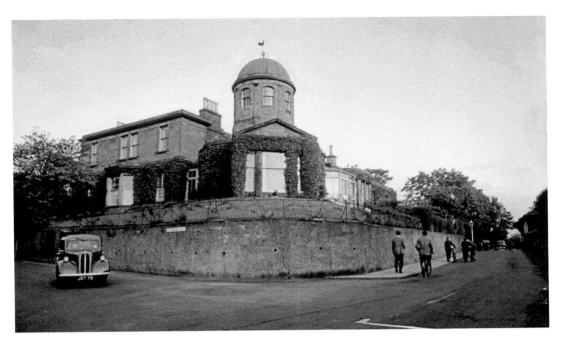

Ardkeen Tower, Culduthel Road, 1950s and 2015

Known as the Observatory Building, Ardkeen Tower was originally a school. Standing on the corner of Culduthel Road and Old Edinburgh Road, the foundation stone was laid in May 1834. A bottle containing coins, an almanac and copies of each of the Inverness newspapers was deposited within a stone cavity in the tower at the foundation ceremony. It was originally approached by a flight of steps from the corner of the streets with the entrance hall under the dome.

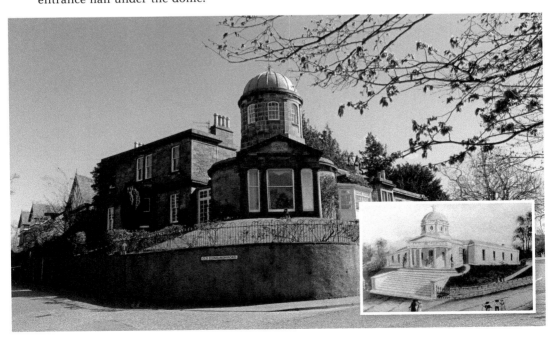

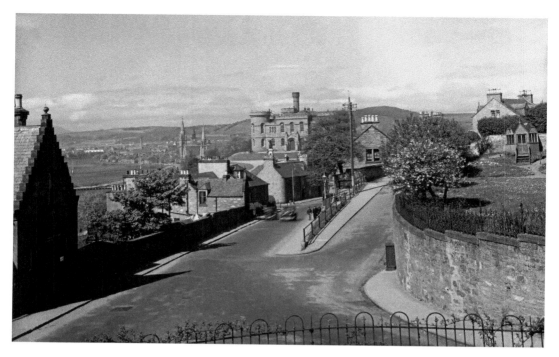

Inverness Castle from Ardkeen Tower, 1933 and 2015

The castle and the tower were both designed by William Burn, and the building of them both began on the same day in May 1834. The ancient name for Castle Road leading up the hill was Doomsdale Street, and was the route taken by prisoners to their place of execution on Gallowmuir. To the right is the walled garden area of Viewhill House.

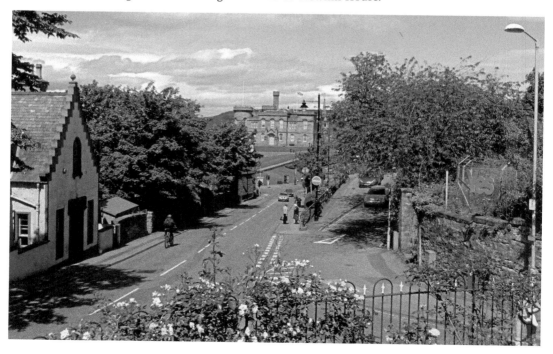

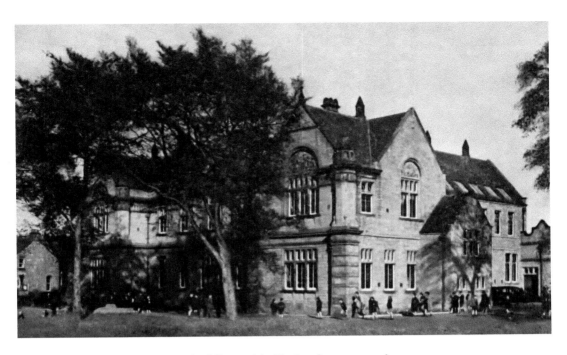

Inverness Royal Academy building, Midmills Road, *c.* 1930 and 2015

This historic B-listed building is the former home of the city's oldest school – Inverness Royal Academy – and sits in 4.2 acres of land in the Crown conservation area. The IRA outgrew its original buildings within the town and moved to Midmills Road in February 1895. It moved again to a modern building in Culduthel in 1978. It is currently for sale and the more recently-built non-listed extensions will be demolished to pave the way for new development.

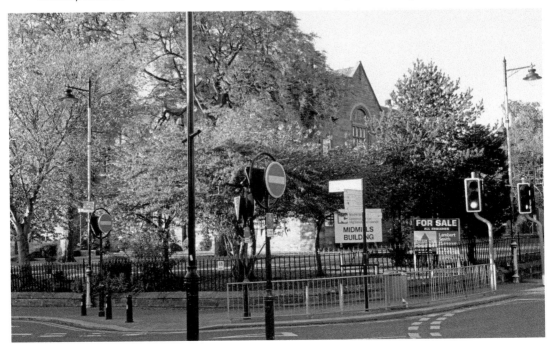

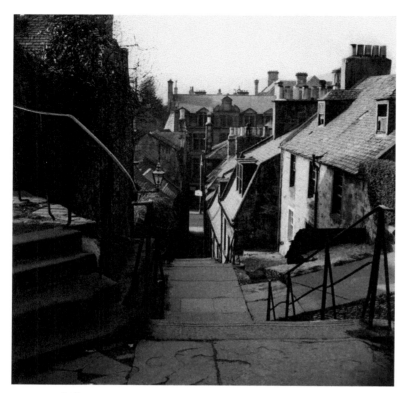

Raining's Stairs, 1930s and 2015 Leading from Ardconnel Street down to Castle Street, Raining's Stairs show the steepness of the escarpment that Inverness backs on to. In 1726 John Raining, a Norwich merchant, bequeathed £1,200 to support building charitable schools in the Highlands. A school at the end of Ardconnel Street was built in 1757 with extensions added in 1840 and 1881. It closed in 1894 and the building demolished in 1976. The houses that flanked both sides of Raining's Stairs have also long gone.

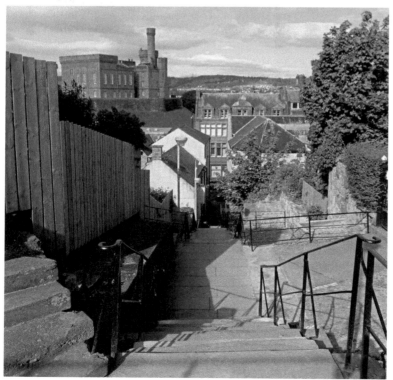

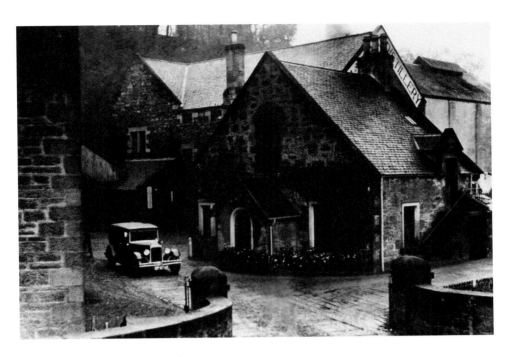

Millburn Distillery, 1930s and 2015

Founded as Inverness Distillery in 1807, it produced single malt Scotch whisky. The oldest and longest running of Inverness's distilleries, the business changed hands many times. In 1904, its name was officially changed to Millburn and in 1922 it was severely damaged by fire. The distillery closed in 1985 and in 1988 many of the buildings were demolished to allow for the property to be re-developed. In 1989 it became The Auld Distillery Restaurant and is now a Premier Inn.

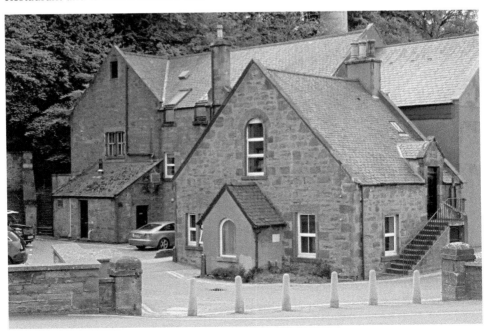

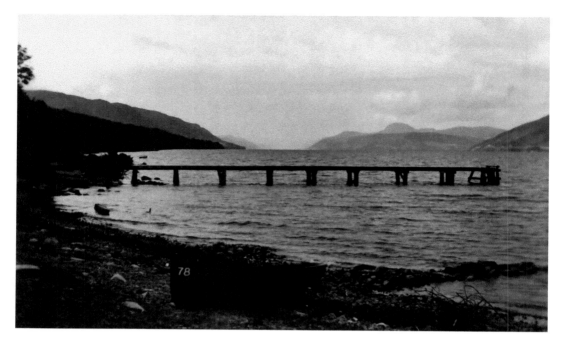

Loch Ness and Dores Pier, 1930s and 2015

Dores village is located on the south shore of Loch Ness, just over 6 miles from Inverness. It is part of the Great Glen, the fault line which runs over 60 miles between Inverness and Fort William. The loch is the largest body of fresh water in Britain with more water in it than all the other lakes of England, Scotland and Wales combined. It has a depth of 754 feet and could hold the population of the world ten times over.

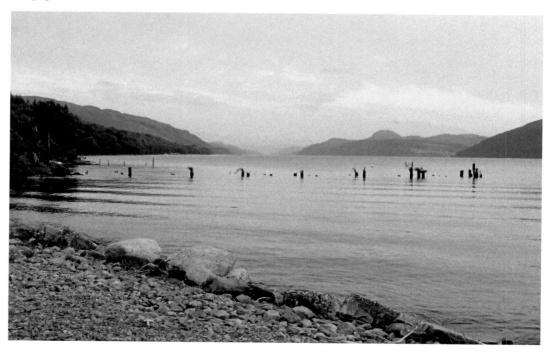

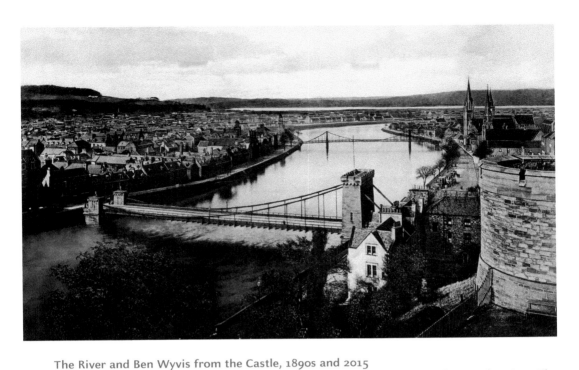

The River and Ben Wyvis from the Castle, 1890s and 2015

This iconic view has been replicated thousands of times by photographers and artists. The River Ness is about 12 miles long and flows from Loch Ness, through Loch Dochfour, and into Inverness, with a total fall in height of about 52 feet before discharging into the Beauly Firth. The first sighting of the Loch Ness Monster was in the River Ness in AD 565, when St Columba is said to have banished a 'water monster' after it tried to attack one of his disciples.

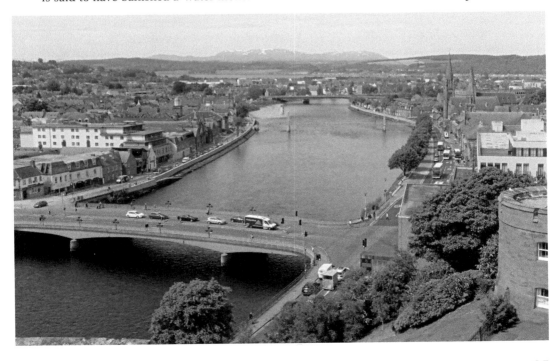

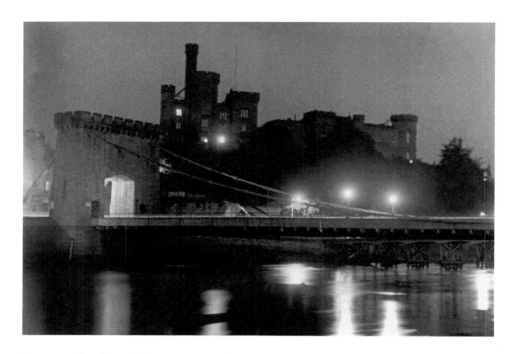

Inverness Castle at Night, *c. 1940s and 2015*

Inverness is regarded as the capital of the Highlands. Awarded city status in 2000, it is the one of Europe's fastest-growing cities. The population grew from an estimated 51,610 in 2003 to 62,470 in 2011. Inverness is ranked fifth out of 189 British cities for its quality of life, the highest of any Scottish city. In 2014, one survey described Inverness as the happiest place in Scotland and the second happiest in the United Kingdom.

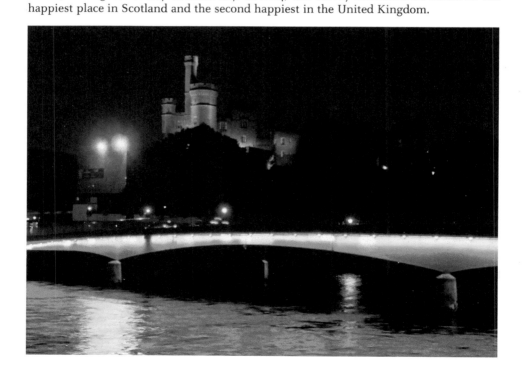